IMAGES
of America

WHITMAN

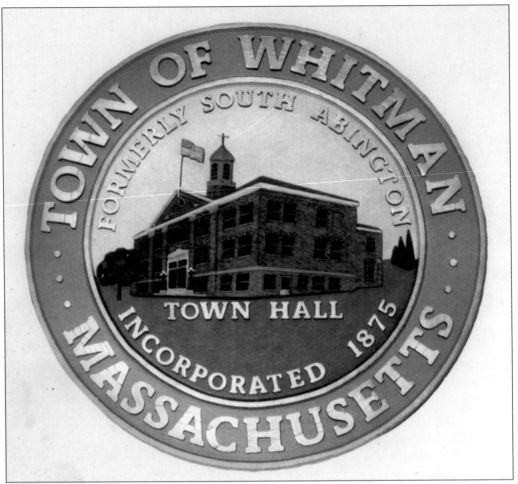

THE TOWN SEAL. The current seal was designed by then town clerk Mildred McKenna and was put into use on January 2, 1975. The new seal replaced the town's old, much simpler seal in celebration of the town's 100th birthday.

IMAGES
of America

WHITMAN

David Hickey

ARCADIA

First printed in 2003.

Published by Arcadia Publishing,
an imprint of Tempus Publishing Inc.
2A Cumberland Street
Charleston, SC 29401

Printed in Great Britain.

Library of Congress Catalog Card Number: 2003105432

For all general information, contact Arcadia Publishing:
Telephone 843-853-2070
Fax 843-853-0044
E-mail sales@arcadiapublishing.com

For customer service and orders:
Toll-free 1-888-313-2665

Visit us on the Internet at www.arcadiapublishing.com.

*Dedicated to my parents, Richard and Allana Hickey,
who are always there with love and support.*

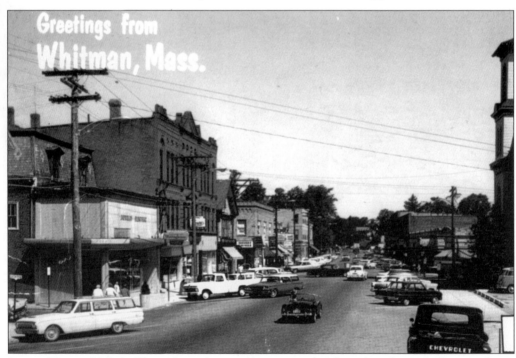

SMALL TOWN, U.S.A. Throughout America are towns that have lost their small-town charm as they have grown. Whitman Center, pictured here, continues to serve the town's residents with modern amenities while retaining its yesteryear appeal.

CONTENTS

ACKNOWLEDGMENTS

First and foremost, love and thanks goes to my wife, Corey, whose constant support makes it possible for me to complete such projects. To my children Shawn, Sam, and McKenna, thank you for your patience and understanding while daddy was endlessly preoccupied.

There are also several other people and organizations I would like to thank, without whom the completion of this book would not have been possible. Thanks to the Dyer Memorial Library for providing many of the images in this book. I was assisted by the library's extremely competent staff, Pam Whiting, and director Joice Himawan. Thanks to Kenneth Taylor and the Historical Society of Old Abington, Pat Pierce and the Whitman Historical Commission, Frank Lyman, Herb and Alyce Arsenault, Linda Shea, Charles Davenport, Nick Pasquale, Jill Anderson, and the staff at Arcadia Publishing.

Special thanks go out to Kerry Keene, John Campbell, Natalie Powell, Eunice McSweeney, and the Whitman Historical Society and Museum, who provided on a daily basis many images and much input.

To all the people of Whitman, past, present, and future, I thank you for the privilege of allowing me to provide you with a glimpse into the town's great history. I encourage you to visit and support the Whitman Historical Society and Museum, located in the old Commonwealth Shoe Building at 7 Marble Street so they may continue their efforts of historical preservation and education.

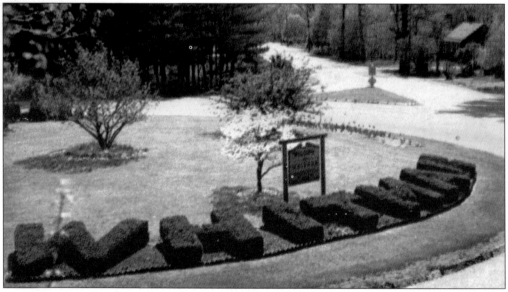

THE WHITMAN ROTARY. Expertly maintained shrubbery spells the town's name on the green of Whitman's only rotary, which joins Plymouth Street, Raynor Avenue, and Essex Street.

INTRODUCTION

Acquired during what is known as the Bridgewater Purchase of 1649–1650, the land that makes up today's Whitman has enjoyed a storied history. The town's history began as early as the late 1600s with what was known as the Little Comfort section of Bridgewater.

In 1693, John Gurney and John Porter, two of the town's prominent early residents, settled here to start a mill on the Schumatuscacant River. The mill marked the beginning of some of the earliest industry in the area.

Throughout the 1700s, many events began to shape and define the area. In 1711, Daniel Axtell, a tanner, moved here and built his tan vats on the Chard Place, which was located just southeast of the present junction of Washington and Walnut Streets. His contract with a local shoemaker was the beginning of the town's later and very prosperous shoe industry.

In 1712, about two-thirds of the current Whitman was incorporated as part of the new township of Abington. It would not be for another 163 years until Whitman, known then as South Abington, would stand on its own.

The year 1729 saw the birth of Col. Aaron Hobart, who played a significant role in both the town's and the country's rich history. By 1769, Hobart was casting church bells and advertising them in Boston newspapers, as he became the country's first regular bell caster. In July 1776, when bells rang to celebrate the signing of the *Declaration of Independence*, most of the bells heard were Hobart bells. When Paul Revere obtained contracts to cast church bells in Boston, he came to Hobart to learn and master the craft. In 1775 and 1776, Hobart received a contract from the government to supply cannons to the troops in preparation for the Revolutionary War. After many failed attempts to successfully cast the cannon, Hobart finally mastered the process in time to fulfill his government contract. Hobart went on to serve in the state legislature for 14 years and took part in the creation of the frigate USS *Constitution*, more affectionately known as Old Ironsides. After a lack of proper white oak trees halted the production of the ship, it was at Hobart's mill that the 40-foot-long, 7-inch-thick wale planks were cut from native trees, thus allowing for the completion of the famed vessel.

During this time, the town also had the distinction of having the oldest and youngest soldiers in the Revolution, as well as a participant in the Boston Tea Party. In 1775, 69-year-old David Porter joined the ranks and marched to Roxbury. In 1777, seven-year-old Samuel Gurney signed on as a fifer. Dressed as a Native American, Benjamin Gardner Jr. of Beech Hill was involved in the world's most famous tea party.

Postwar industries were slow to develop beyond local markets. Only after many locals developed machinery and methods for their use did industry began to flourish. Residents started to set up more permanent institutions, such as churches and schools, that began to define a more localized community.

As the machine age was ushered in, old industries like tack manufacturing became much more profitable as a machine invented by Jesse Reed could cut and head tacks in a single operation. Although there were as many as six different companies making tacks, only the D.B. Gurney Tack Factory on Washington Street, which opened in 1825, is still in full operation today, over 175 years later.

In 1858, Lyman Blake revolutionized the shoe industry with his invention of the shoe sole sewing machine. In addition to saving thousands of hours in manpower while increasing shoe production, this machine, which was financed and marketed by Gordon McKay, proved

invaluable to the Union, as the north was able to keep the soldiers properly shoed during the Civil War.

After Fort Sumter in South Carolina fell to the Confederacy in April 1861, Pres. Abraham Lincoln issued a call across the Union for volunteer militias. Under the command of Capt. Charles F. Allen of 113 Temple Street, the Company E 4th Regiment of the Massachusetts Volunteer Militia assembled on April 16, 1861, at their Washington Street armory. In a blowing nor'easter, the company marched to the east end train depot and boarded a train for Boston. Although the orders were to meet at the Boston Common, Captain Allen marched his men through the storm all the way to the state capitol and signed in there at 8:15 a.m., becoming the first company of the Union Army to report for duty in the Civil War.

As the early industries began to die out, more industrialized ones flourished, and a prosperous shoe industry dominated. Many famous makers, including the Commonwealth Shoe and Leather Company, who manufactured the famous Bostonian shoe line, remained in operation well into the 1970s.

On March 4, 1875, the southerly part of Abington and the Auburnville section of East Bridgewater became one as they branched off to form the township of South Abington. Eleven years later, in 1886, a popular vote changed the name to Whitman in honor of a prominent local family.

Although the town's history began well before its incorporation and subsequent name change, it certainly did not stop there. As the 19th century turned, new people, places, and events have carried on the town's storied historical tradition. Whitman High School Class of 1899 graduate Leila Gurney became a teacher and noted local historian. Ruth Wakefield and her famous accidental Toll House cookie recipe earned and continue to hold worldwide fame, and local baseball players Frank Kane and Johnnie Benson reached the major leagues.

In this book, you see the town's history through images and words meant to recall many of Whitman's special moments. *Whitman* provides nostalgic snapshots of the early history of this remarkable little place.

One

WHITMAN CENTER

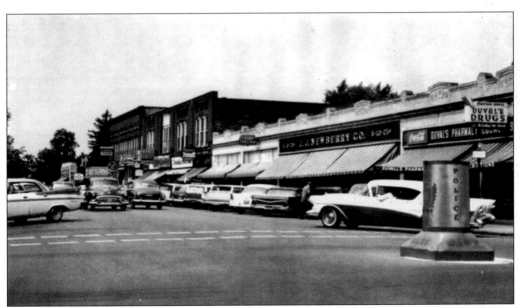

WELCOME TO WHITMAN CENTER, THE 1950S. The most recognizable item in this picture from 50 years ago is the familiar police stand. The stand remained a mainstay at this intersection well into the 1990s. Clearly seen amongst the stores is J.J. Newberry Company—everyone's favorite five-and-dime. Newberry's was accessible not only through this Washington Street door, but also via a door on South Avenue.

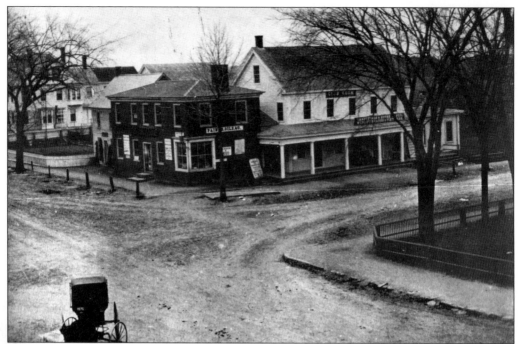

THE CORNER OF WASHINGTON STREET AND SOUTH AVENUE, C. 1875. The buildings in this picture occupy the same corner where Duval's Pharmacy is now located. Although the buildings and businesses have changed throughout the years, this corner has remained the cornerstone of the center's commerce for well over 100 years.

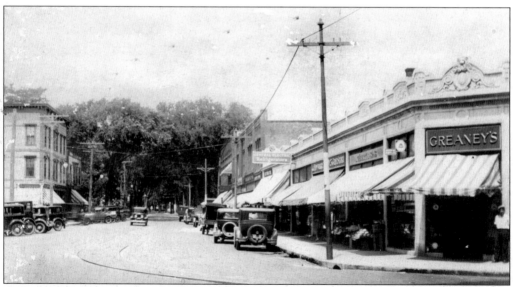

WHITMAN CENTER, LOOKING NORTH, THE MID-1930S. Years before Duval's Pharmacy took over this corner, it was occupied by many other businesses. In addition to Greaney's, this prime spot was occupied by Call's, which sold everything from cigars to candy, and later became Johnson's Drug Store.

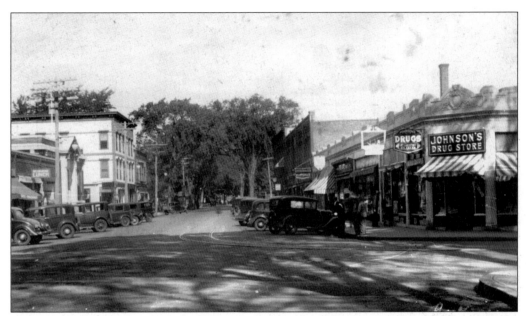

THE VIEW UP WASHINGTON STREET, C. 1935. In this photograph, looking north up Washington Street on a fine, sunny day, the busy center resembles a typical day today. The cars however, now come in a few more shapes, makes, and colors.

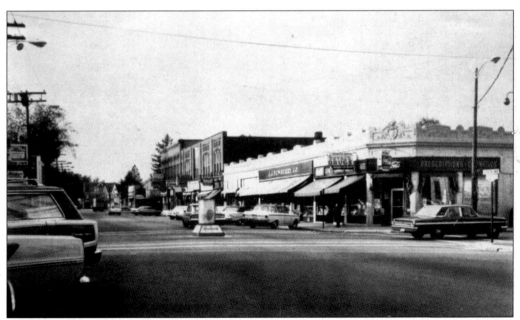

WHITMAN CENTER, THE 1970S. In this later view up Washington Street, the entrance to Duval's Pharmacy is still on the corner of the building. The police stand remained for many years after this photograph was taken.

11

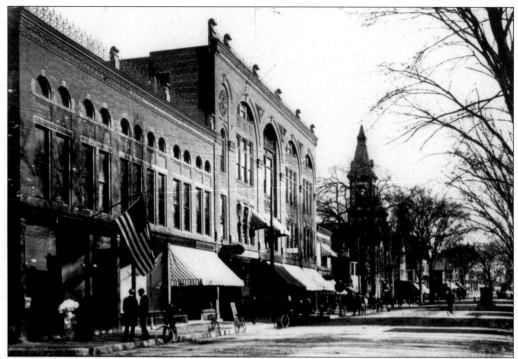

THE NORTHEAST BUSINESS BLOCK, THE 1890s. In this photograph, the huge Jenkins Block building is seen as one of Whitman's early skyscrapers. This stunning building suffered two major fires prior to a third one in 1930 that gutted the entire brick frame.

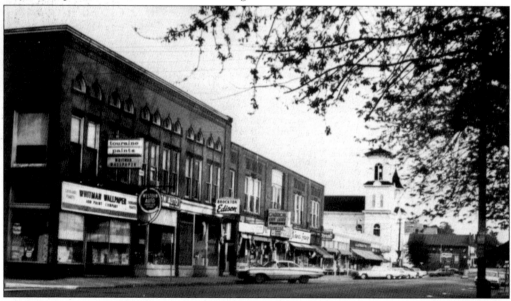

WHITMAN CENTER, WASHINGTON STREET, LOOKING SOUTH. This photograph was taken from the corner of Gold Street in the late 1960s. The Baptist church looms large over the center on the right. The stores seen here are, from left to right, Whitman Wallpaper, Western Auto, Brockton Edison, Set 'N Spray, Carroll Cut Rate, Nanci Jane, Hovey's Drug, Sally's Dress Shop, J.J. Newberry Company, and Duval's Pharmacy.

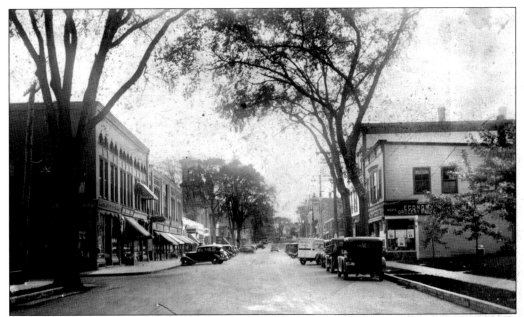

WASHINGTON STREET, LOOKING SOUTH, C. THE 1930S. Unlike the huge warehouse stores of today, little markets were the norm many years ago. In this photograph the Economy Grocery Store is clearly visible on the right. Directly across the street, on the corner of Whitman Avenue, is the Whitman Public Market. Also visible is the new building that replaced the much larger Jenkins Block, which burned in February 1930.

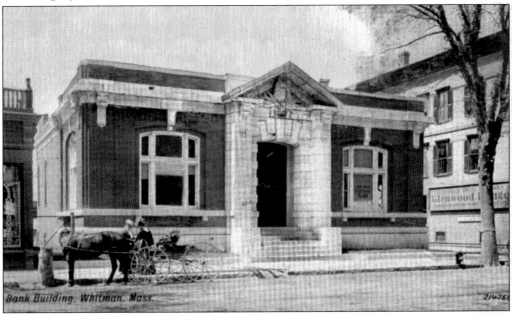

Bank Building, Whitman, Mass.

THE WHITMAN SAVINGS BANK BUILDING, THE EARLY 1900S. The stately brick building, along with the three-story apartment to the right, were torn down in the mid-1960s. The new Whitman Savings Bank was built on the site of the apartment building and was later renamed Abington Savings Bank. Customers may recall the manhole-cover-sized coin in the lobby of the original brick building.

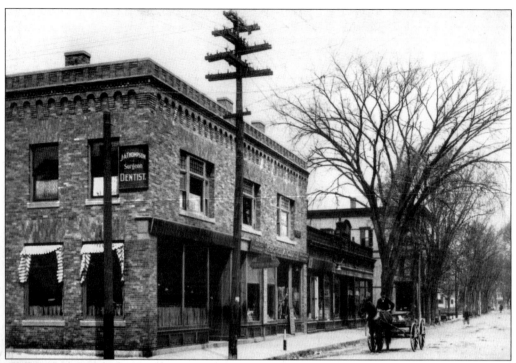

THE CORNER OF WASHINGTON AND TEMPLE STREETS, C. 1900. This corner is now the site of the Mutual Federal Bank. In addition to the second-floor dentist's office, the Whitman National Bank and the Whitman Savings Bank occupied much of this building. Located in the building just beyond the horse wagon was Clift's choice grocery market.

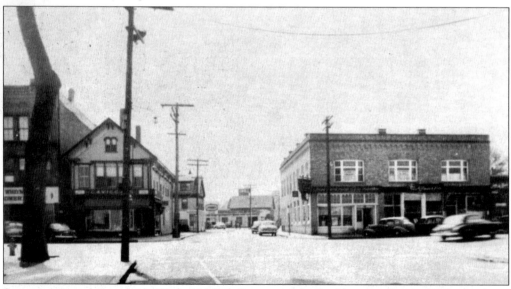

SOUTH AVENUE, LOOKING WEST. Although some of the buildings in this c. 1950 view have been restored or replaced, the similarity some 50 years later is uncanny. Although the tenants have changed over the years, anyone who knows Whitman Center will recognize the buildings as Mutual Federal Bank and Mary Lou's coffee shop.

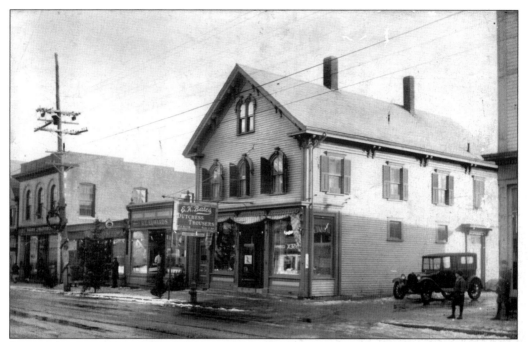

SOUTH AVENUE, THE 1920S. This view down South Avenue at Church Street shows how the more things change, the more they stay the same. All of the buildings to the left of Church Street are still standing and remain remarkably similar today.

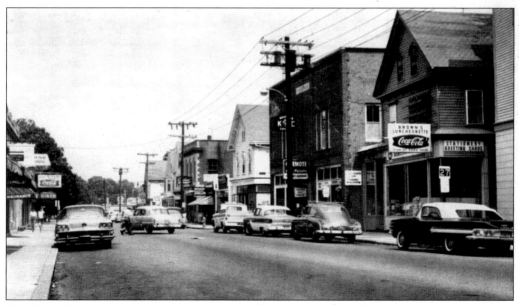

THE EAST SIDE OF SOUTH AVENUE, C. 1960. In this view of South Avenue are Brown's News and the Freeman Block, which housed Freeman's Hardware (right). The sign for the Whitman Diner is seen on the left.

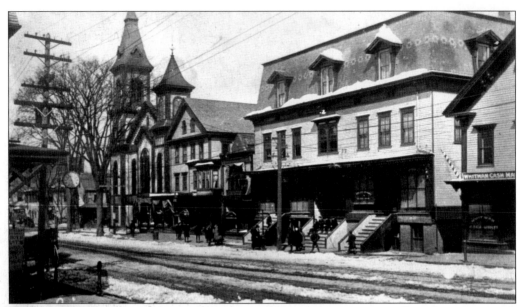

WASHINGTON STREET, LOOKING NORTH, C. 1900. Seen is an unusually calm morning on Washington Street about 100 years ago, when many huge trees were curbside and trolley tracks lined the streets of the town. Looking at the southeast side of Washington Street, you can see the Harding and Village Blocks on the right. The steeple of the old Baptist church stands tall in the background.

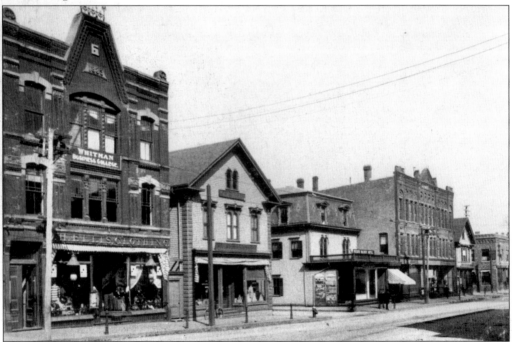

THE SOUTHWEST SIDE OF WASHINGTON STREET, C. 1900. In this view of Washington Street, the O.H. Ellis Clothing store is clearly visible. The building on the left also housed the Whitman Business College, which has since closed. The building underwent a major interior restoration in 2003, but the outside has remained relatively unchanged.

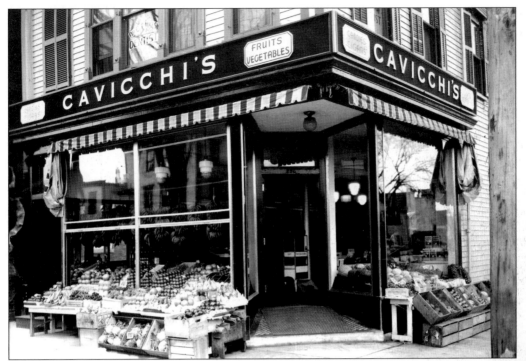

CAVICCHI'S MARKET. Very few local establishments can boast a legacy as long-lasting as Cavicchi's, which opened in 1890. In Whitman, Cavicchi's was a longtime local gathering place. Cavicchi's offered every imaginable fresh fruit and vegetable, as seen in this view. From the store's warehouse on School Street, the market distributed to many other stores in the area.

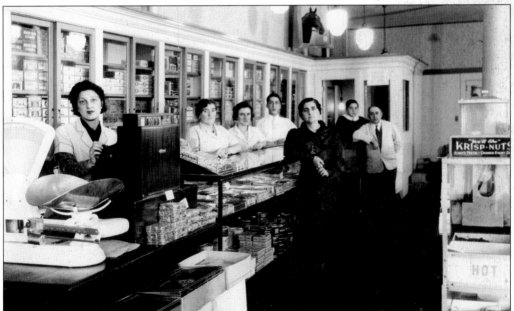

INSIDE CAVICCHI'S MARKET. Pictured here are several of the members of the Cavicchi's staff. Everyone's favorite local market remained operational for many generations. Do you recognize anyone here?

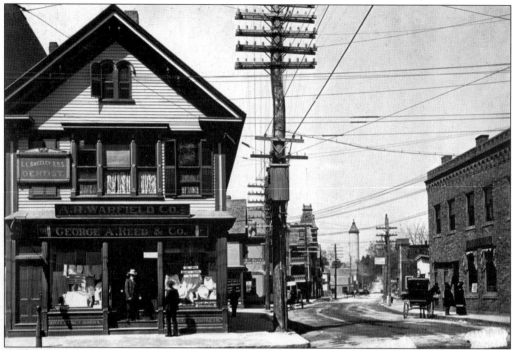

GEORGE A. REED & COMPANY. Although most people remember this building as Cavicchi's, it was George A. Reed & Company prior to that. In this view from the late 1800s, you can clearly see all the way up Temple Street to the water tower.

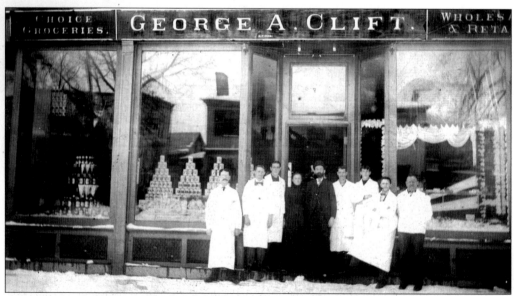

THE GEORGE A. CLIFT STORE, WASHINGTON STREET. The George A. Clift grocery store was located on Washington Street next door to the Whitman Savings Bank. The savings bank was part of the present Mutual Federal building, and the building that housed Clift's is now the parking lot. One of the many benefits of Clift's was home delivery of goods by way of the state-of-the-art horse-drawn grocery wagon.

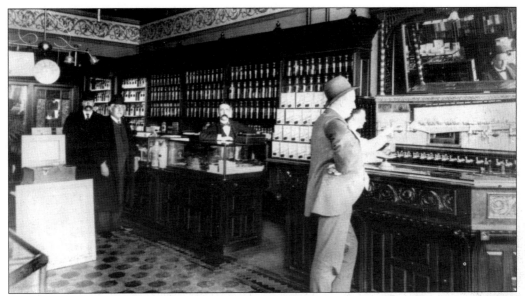

THE INTERIOR OF HOVEY'S, WASHINGTON STREET. The unmistakable interior of the drugstore is pictured c. 1900. Located in the center of town on Washington Street, the store opened its doors in 1893. It was purchased by Duval's Pharmacy in 1972, and it closed in 1975. It was at Hovey's that kids could get their favorite treat at the soda counter, which featured Hovey's Mansion House Ice Cream, while sitting in the old-fashioned chairs that were placed for the comfort of all customers.

THE ANDERTON FUNERAL HOME, THE 1950s. Located at the corner of Washington Street and Whitman Avenue, this building has been replaced by part of Joubert's Clothing. Many of the photographs that appear in this book came from the proprietor's personal collection, which had been donated to the Dyer Memorial Library in Abington.

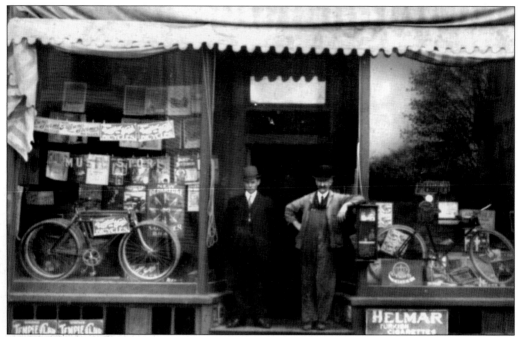

ED PACKARD'S STORE, WASHINGTON STREET. Seen outside of Packard's store are Ed Packard (right) and an unidentified man. A turn-of-the-century Wal-Mart, Packard's store had everything one could want or desire, including spanking new bicycles. Packard's store was next to the current Millie's Lunch. Packard lived in a house behind his store that now operates as Berry Real Estate.

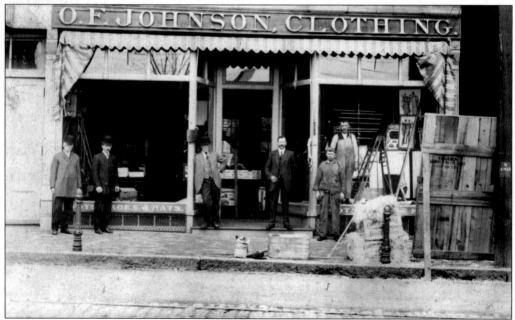

O.F. JOHNSON CLOTHING, C. 1900. Located on the southwest side of Washington Street, O.F. Johnson offered fine men's clothing. In addition to a wide variety of clothes and shoes, the company carried a spectacular collection of hats.

THE WHITMAN CENTER CHRISTMAS TREE, 1926. Christmas has always been an exciting time in Whitman for people of all ages. Imagine the excitement of seeing the gigantic decorated tree for the very first time.

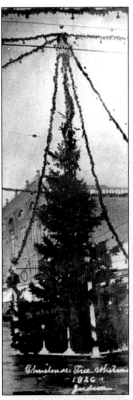

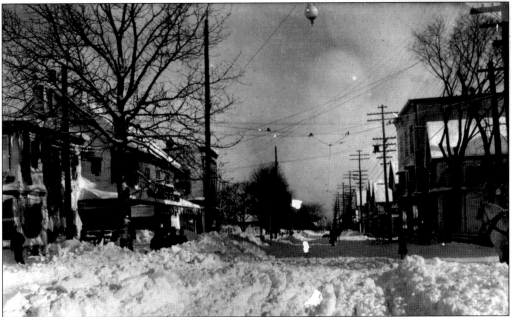

SOUTH AVENUE, AFTER THE SNOWSTORM, THE 1880S. In this view up South Avenue, it is apparent that there was quite a snowstorm. Unlike today's modern snow-moving machinery, the horse-drawn carriages of the time had to make their own way until the spring melt cleared the streets.

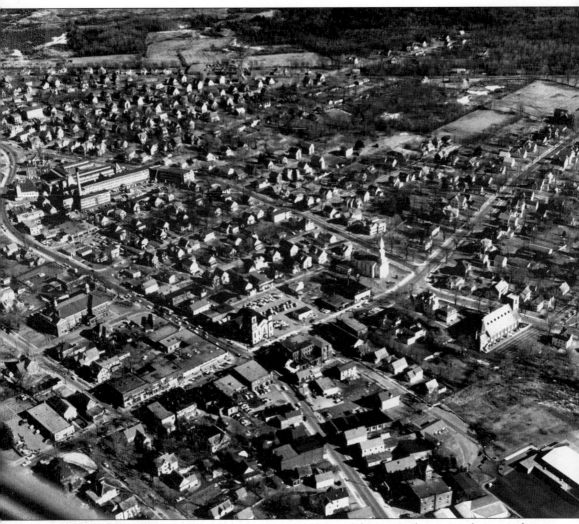

AN AERIAL VIEW OF DOWNTOWN WHITMAN, C. 1963. The entire downtown business district can be seen in this stunning aerial view. A close look reveals many buildings that have since been removed, including the old Whitman Theater, which was on Temple Street.

Two
WHITMAN TOWN PARK

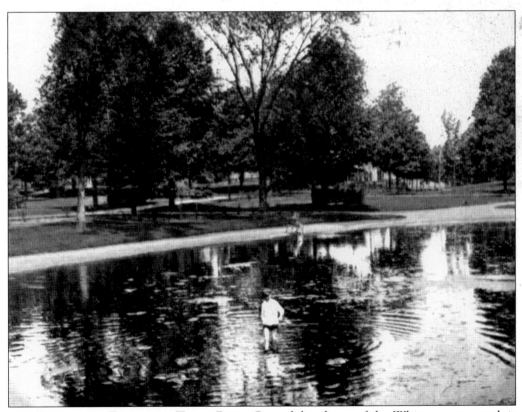

THE REFLECTING POND, THE TOWN PARK. Part of the charm of the Whitman town park is the reflecting pond. Pictured here, a young boy wades through this shallow pond. Recently refurbished, the pond is also a popular spot for skaters throughout the winter.

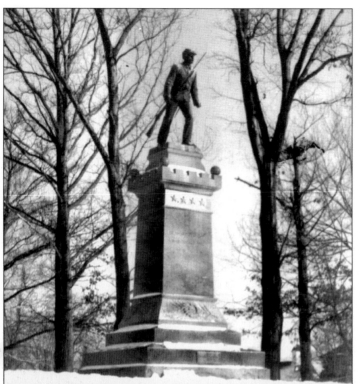

THE CIVIL WAR MONUMENT, THE TOWN PARK. This monument was donated by the George A. Custer Camp No. 11 Sons of Veterans. The memorial was dedicated to all of the men in the army and navy who fought in the Civil War. Dedicated in 1908, the 25-foot monument looks out from atop the hill upon the reflecting pond. The inscription reads, "In Memory of Soldiers and Sailors 1861–1865."

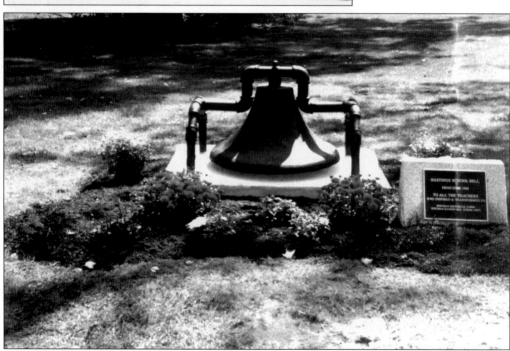

THE HASTINGS SCHOOL BELL. Weighing roughly 300 pounds and measuring 30 inches in diameter, the 16-inch-high Hastings School bell was permanently placed in the town park in 1998, the 100th anniversary of the renaming of the school.

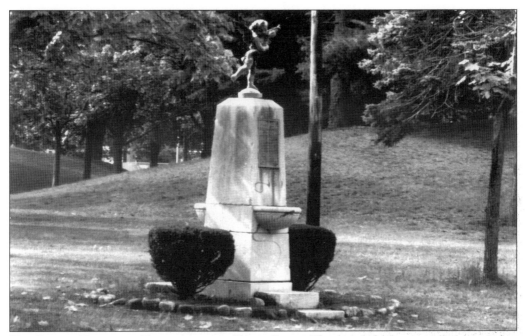

THE PUBLIC DRINKING FOUNTAIN, THE TOWN PARK. This beautiful fountain was donated in 1925 to honor the town's children. The inscription reads, "Given to the Children of Whitman in Memory of Hanna Jane Brigham, Wife of Albert Henry Brigham, to Express His Appreciation of the Respect Shown by Them in Refraining from Using This Playground During Her Illness, 1925."

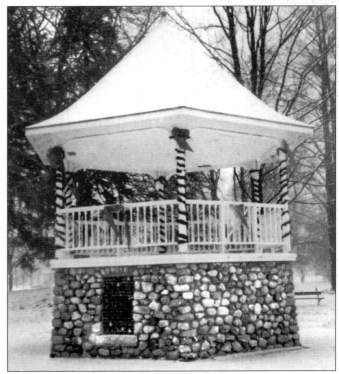

THE PARK BANDSTAND. The park bandstand was constructed in 1908 at a cost of $390. Originally, $350 was appropriated, but it was not enough, as the project ran over budget by $40. Robert McDermott of the Regal Shoe band offered to supply the additional funds needed to complete the bandstand. For many years, weekly concerts were held regularly as the sounds of children playing filled the air. On Memorial Day 1989, the bandstand was rededicated after a long restoration project was completed.

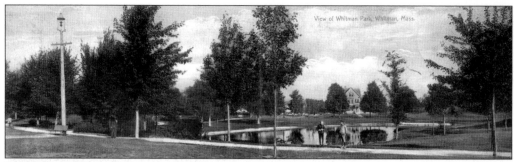

THE TOWN PARK. On March 8, 1880, at a town meeting, it was voted to accept a gift of land from Augustus Whitman. Whitman's only stipulations were that the town keep the land as a public park and that there be a suitable plan adopted for the improvement and beautification of the land. Residents are still enjoying Whitman's vision, as the park has become the focal point of many outdoor activities in the town. The park was designed by legendary landscape architect Frederick Law Olmsted, who also designed Boston Common and Central Park in New York.

THE TOWN PARK FROM WHITMAN AVENUE. Today's park provides entertainment by offering a variety of activities, including baseball, swimming, and sledding. In this view from Whitman Avenue, one of the many walking paths surrounding and bisecting the park invites a stroll.

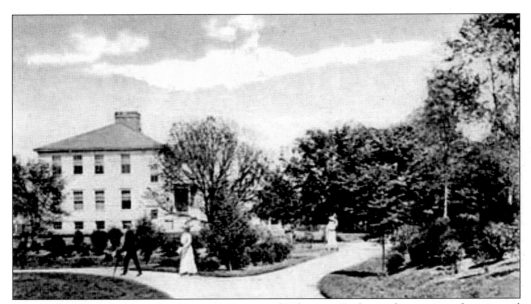

AN AFTERNOON STROLL. In this *c.* 1900 view of Whitman Park, residents enjoy the tranquil surroundings as they take a stroll on a sunny summer day. At this time, the park was primarily used for its wonderful walking trails.

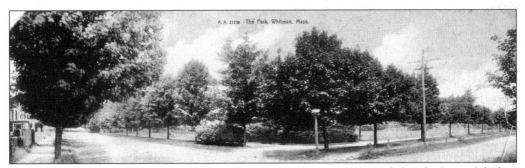

P. R. 21538 The Park, Whitman, Mass.

AN EARLY VIEW OF WHITMAN PARK. Since its beginnings, the park has been modified to serve the town's continuously changing needs. In this view from the corner of Hayden and Whitman Avenues, one can see the much of the undeveloped land that has become the major-league baseball field.

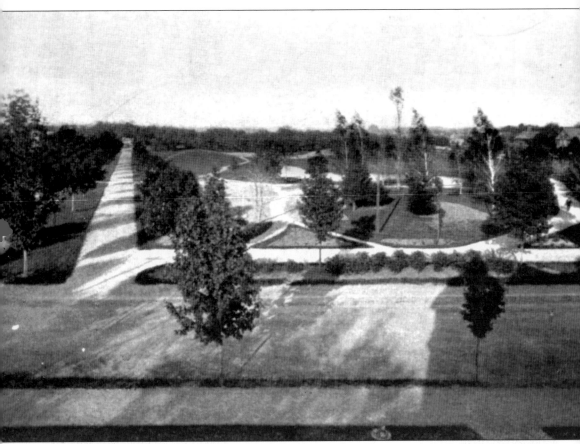

THE ORIGINAL PARK LAYOUT. In the beginning, the park was an undeveloped parcel of land that was converted to a beautiful public park. The conversion required a tremendous amount of time and labor. Many men provided the labor for a respectable wage of $1.50 to $3 per day.

Three
BUSINESS AND INDUSTRY

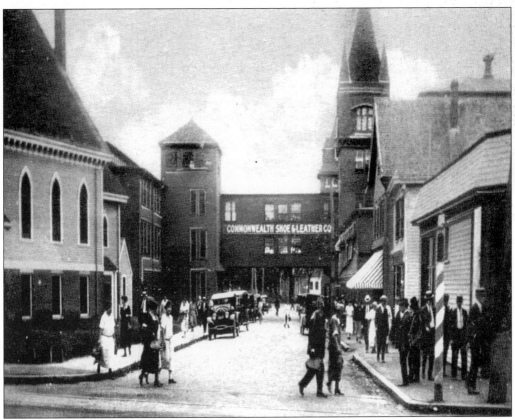

WHAT'S FOR LUNCH? In this *c.* 1920s street scene of Marble Street from South Avenue, workers from the Commonwealth Shoe and Leather Company hit the streets as they take a well-deserved lunch break.

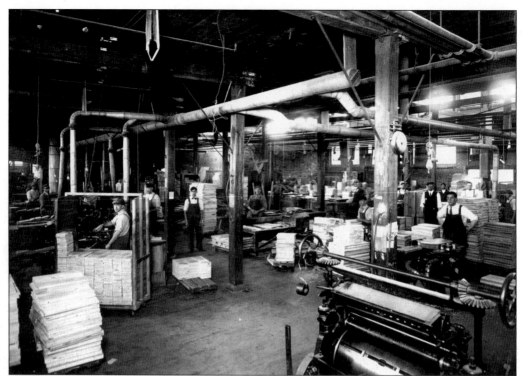

INSIDE THE ATWOOD BROTHERS PLANT, 1906. Located on Pond Street, the Atwood Brothers plant made wooden boxes and shoe racks. The Atwood Brothers made wooden boxes of every size, shape, and description. One of their specialties was a shoe rack with Victor ball casters that did not clog while being wheeled around the old factories.

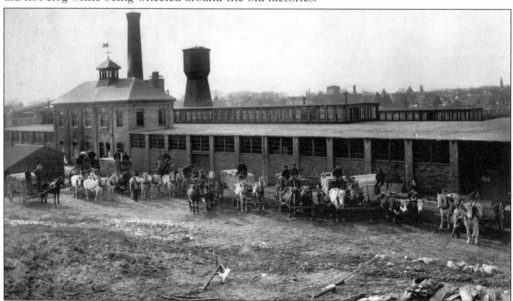

THE ATWOOD BROTHERS PLANT. The factory was operated so well that it recycled the wooden shavings to fuel the furnace sufficiently to provide all necessary steam for the entire plant. The factory still stands and is the home to a variety of businesses today.

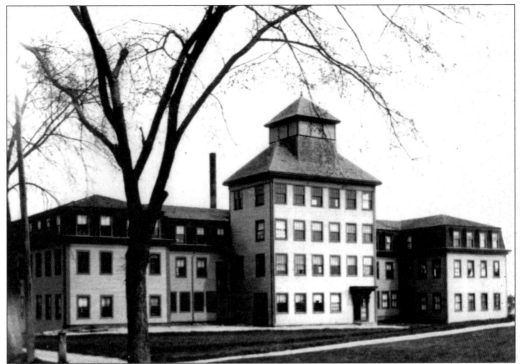

HOLBROOK & KEENE. The largest cutter of calfskins for shoe vamps in the country, the Holbrook & Keene Company, which was located on Washington Street, provided material to some of the finest shoemakers in the industry.

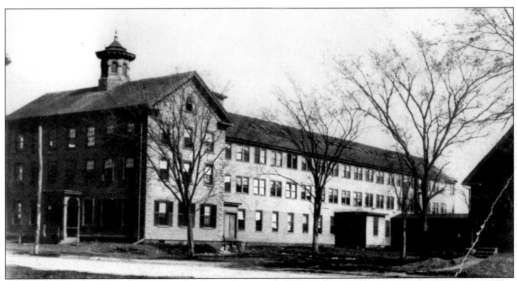

THE UNITED STATES SHOE COMPANY. Located on South Avenue between Hobart Square and Brigham Street, the United States Shoe Company operated in an enlarged building originally used for other manufacturing purposes. The company manufactured men's shoes for the New York and Western trade.

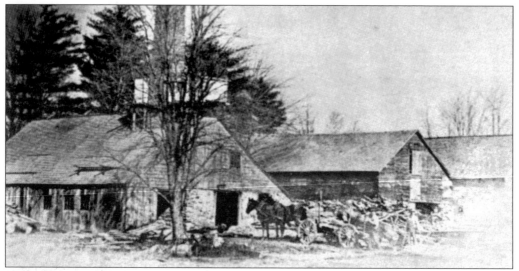

THE HOBART MILL SITE. Located at the corner of South Avenue and Pleasant Street, the Hobart Mill produced the wale planks for the frigate U.S.S. *Constitution*. Originally powered by water, owner Col. Aaron Hobart erected a "big chimney" on this site in 1859 to serve as an exhaust for the state-of-the-art steam power.

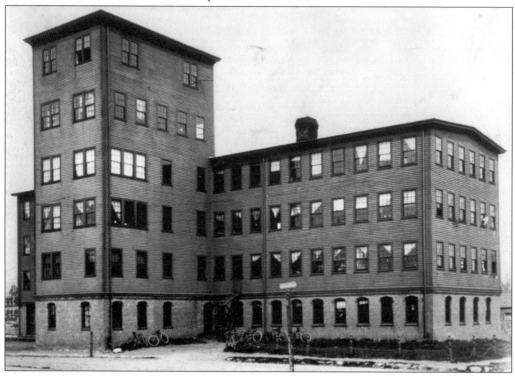

THE OLD COLONY BOOT & SHOE COMPANY. Managed by Miller Cook Jr., the Old Colony Boot & Shoe Company was one of the earliest shoe companies on the South Shore. From their Whitman Avenue location, they manufactured medium- to high-grade men's boots and shoes. Although the company sold directly to retailers, the bulk of their product was sold by a New York distributor.

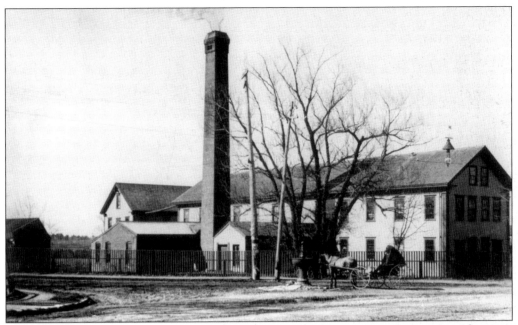

THE WHITMAN PAPER BOX COMPANY. As a manufacturer of paper boxes, this plant was located at the corner of South Avenue and Pleasant Street. Making mostly shoeboxes, their trade was mostly with local shoe manufacturers. The plant was capable of producing thousands of boxes daily.

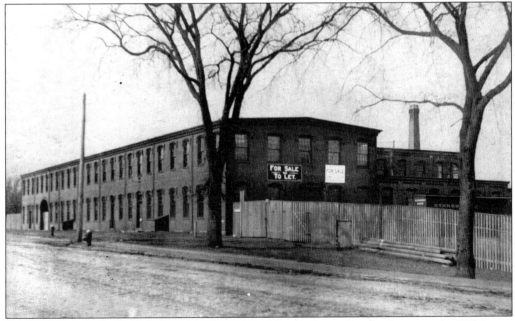

THE WHITMAN MANUFACTURING COMPANY. Located on South Avenue, the Whitman Manufacturing Company plant still stands to this day. Built on roughly four acres in the east end of town, two separate steam plants were required to operate the huge structure. The main building offered over 65,000 square feet of floor space. The shipping room is connected directly to the tracks of the New York, New Haven & Hartford Railroad.

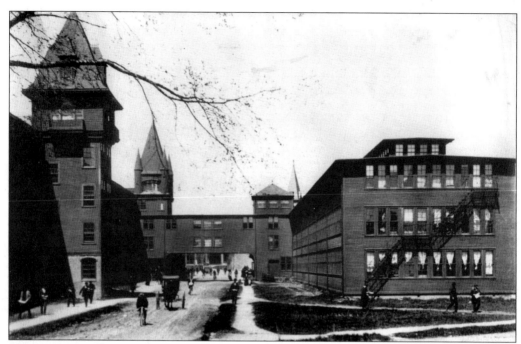

THE COMMONWEALTH SHOE AND LEATHER COMPANY. The Commonwealth Shoe and Leather Company bought out the Smith and Stoughton Company and acquired the Bostonian trademark *c.* 1896. Commonwealth made this line of shoes world famous and provided the navy with shoes through World War II. In 1970, Commonwealth sold out to Kayser-Roth to end its history of fine shoemaking in Whitman.

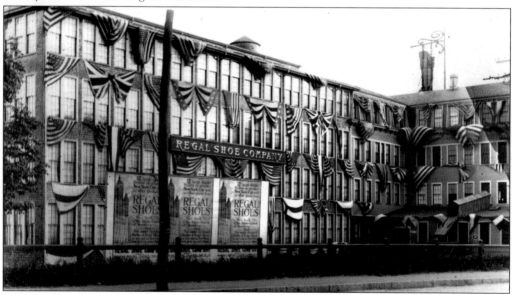

THE REGAL SHOE COMPANY, SOUTH AVENUE. A very patriotic Regal Shoe Company is pictured here. Billboard-sized signs on the side of the building read, "17 large double stores in greater New York City sell no other goods than Regal shoes. New York is the style-centre of America, and the same identical styles of Regal shoes as are sold in New York are now on sale here."

JENKINS BROTHERS & COMPANY. In addition to operating the plant on Warren Avenue, this maker of leather board, leather-board counters, and steel and leather-board boot and shoe shanks also operated a plant in Bridgewater. For many years, the company also manufactured caskets, in addition to owning the largest business block in town.

THE D.B. GURNEY FACTORY. As a manufacturer of tacks and nails, the D.B. Gurney Company started business as early as 1840 in Abington. The company moved to South Abington c. 1875, where it has remained in continuous service ever since. The factory was also home to many other businesses and industries. The D.A. Gurney Company manufactured steel and leather-board shanks; the C.P. Slack Company manufactured shoe cases, lumber, and cordwood; and the Clark Manufacturing and Novelty Company made and sold wooden novelties.

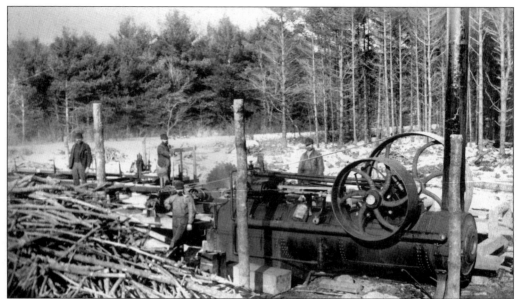

THE FIRST PORTABLE SAWMILL. Lumbering was a prosperous industry in the early days of the town. Pictured here is the first portable sawmill in the area. This sawmill significantly increased productivity.

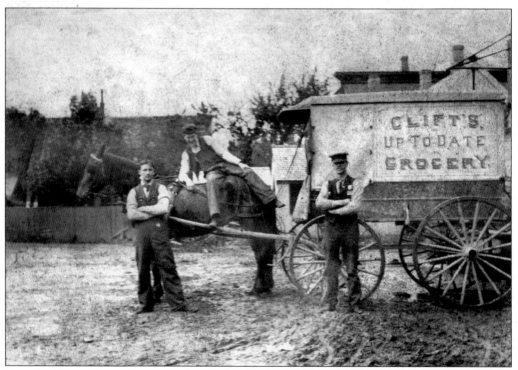

CLIFT'S UP-TO-DATE GROCERY CART. Seen here is Clift's grocery cart. Running from Clift's on Washington Street, the grocery cart could quickly deliver goods to even the furthest parts of the township.

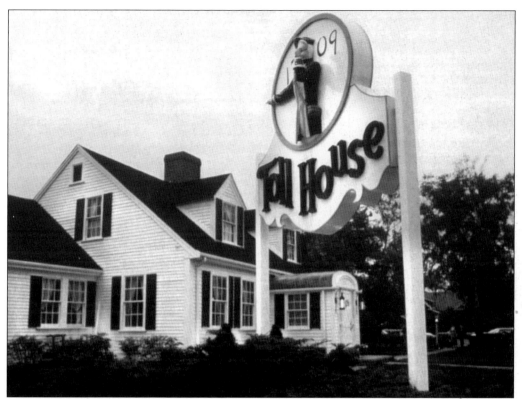

THE HOME OF THE WORLD-FAMOUS TOLL HOUSE COOKIE. Purchased in 1930 by Kenneth and Ruth Wakefield, the Toll House Restaurant burned to the ground on December 31, 1984. The famous sign still stands today and the Toll House, although gone, will continue to be remembered with every batch of freshly baked cookies.

THE BLACKSMITH SHOP RESTAURANT. Located at the corner of Bedford and Temple Streets, where Cumberland Farms is now, the Blacksmith Shop Restaurant offered a fine dining experience. The menu offered the patrons their choice of lobster, steak, fish, or chops, all of which were broiled over the coals of the old forges.

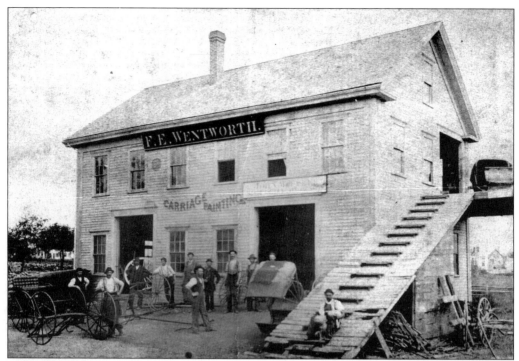

THE F.E. WENTWORTH CARRIAGE PAINTING COMPANY. Just like today's cars, the vehicles of yesteryear needed tune-ups occasionally. Pictured here is the F.E. Wentworth carriage painting company, which provided just the touch needed to refurbish any stressed buggy.

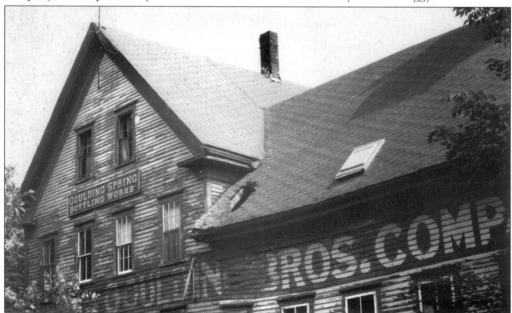

THE GOULDING BROTHERS COMPANY. From its location on Corthell Avenue, the Goulding Spring Bottle Works offered many different flavors to satisfy everyone's taste. In addition to the typical flavors of lemon-lime, cola, and cream soda, Goulding's quenched the thirst for those who craved nerve tonic, celery tonic, or sarsaparilla, to name a few.

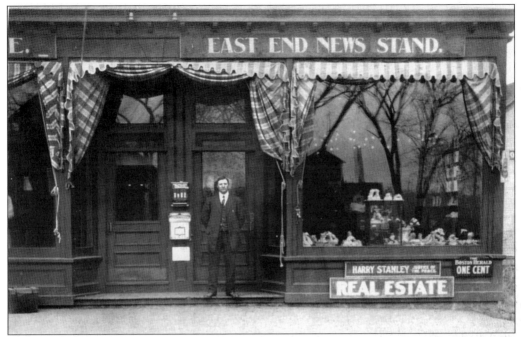

THE EAST END NEWS STAND. Located next to the East End post office on South Avenue, the East End News Stand was a favorite stop for many residents. The sign on the right offers the *Boston Herald* for 1¢, and the bottom sign on the left politely requests "No Spitting."

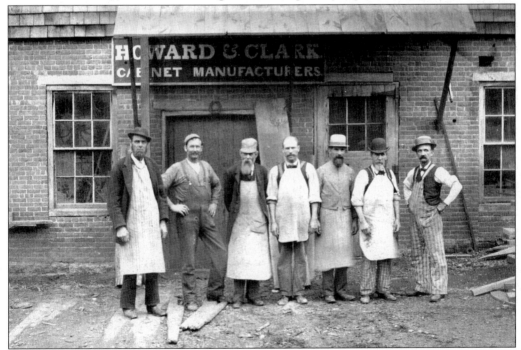

THE HOWARD & CLARK CABINET MAKERS. Pictured here is the staff of Howard & Clark Cabinet Manufacturers. With its attention to detail, this company offered many fine cabinets from its Pond Street plant.

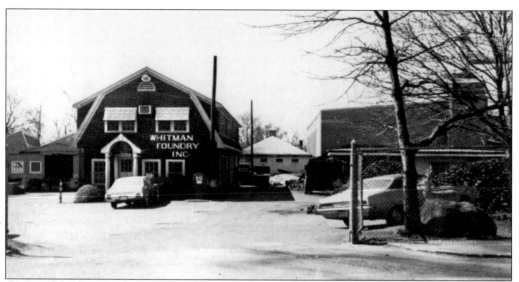

THE WHITMAN FOUNDRY, RAYNOR AVENUE. Serving as the only reminder of our early forges is the Whitman Foundry on Raynor Avenue. Still making iron castings, this factory produced a replica of the anchor of the U.S.S. *Constitution* some years ago.

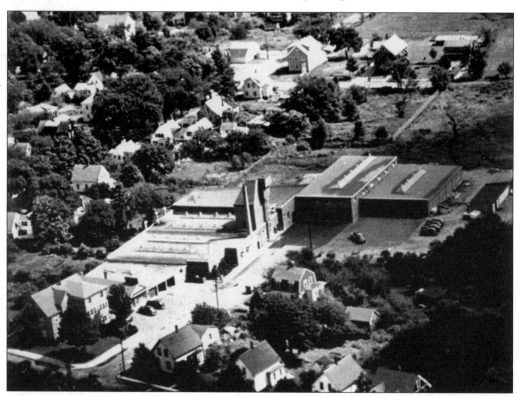

THE COBURN WILBERT VAULT COMPANY, ESTABLISHED IN 1918. In this aerial shot of the Coburn Wilbert Vault Company at the corner of Buckley Avenue and Temple Street, the vastness of the factory complex is apparent. Coburn was aboard the plane from which this photograph was taken.

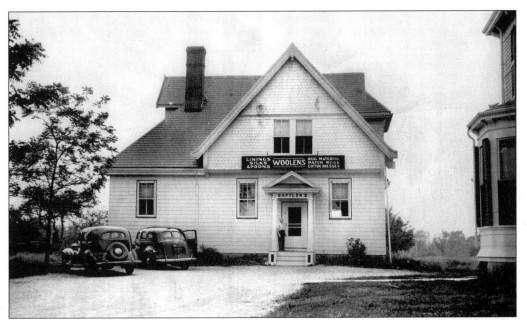

SAFTLER'S, THE 1930S. Looking at this early picture of Saftler's, few could imagine the landmark it would become many decades later. The house visible on the right in this photograph was relocated behind the fabric store on Auburn Street and still stands today.

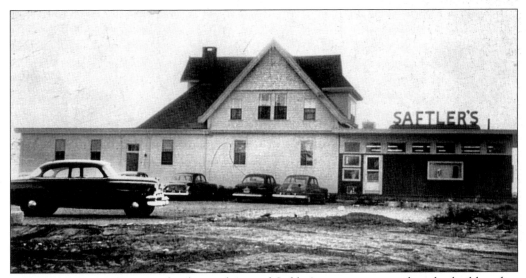

SAFTLER'S, THE 1950S. In this later edition of Saftler's, it is apparent that the building has been through a major expansion. The original structure that was the fabric store is clearly visible as the center portion of the modified version.

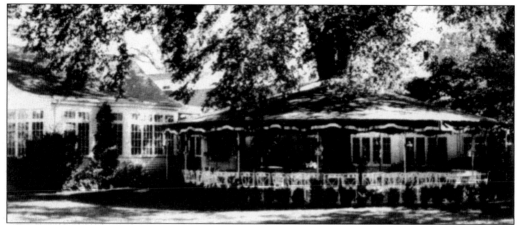

THE TOLL HOUSE CAROUSEL. Anyone who ever had the pleasure of dining at the Toll House Restaurant may remember the carousel room. Located in the rear of the restaurant, the room was built around the huge oak tree seen here. The tree seems to sprout from the roof of the building.

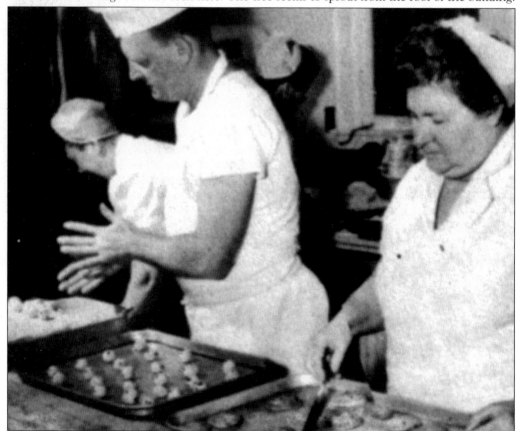

EVERY THREE MINUTES. Every three minutes, a fresh batch of warm Toll House cookies would appear from the hot kitchen ovens to satisfy the demand for the all-time favorite. In 1998, the Commonwealth of Massachusetts adopted the cookie as the official state cookie. Pictured preparing tasty treats are, from left to right, Martha Branley, cookie chef Bill Frasier, Susan Brides, and Annie Alden.

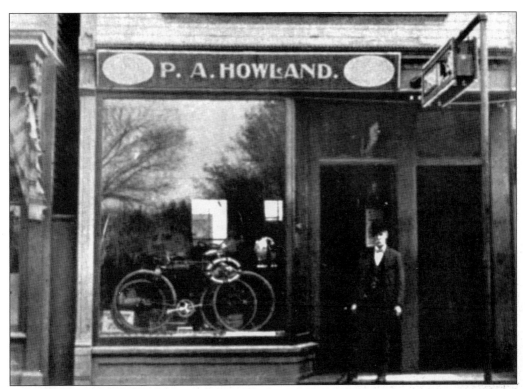

P.A. Howland, Washington Street. The Perez Asbury Howland music store was located between the village hall and the Harding Block on the southeast side of Washington Street. In the former Fred Stebbins music store, Howland wrote his own songs as he played the piano and accordion. This same store later became a record shop and then a gun shop.

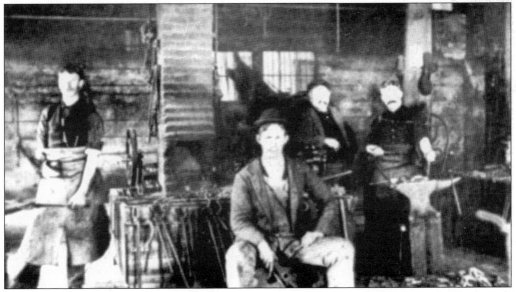

The John Connell Blacksmith Shop. This is an interior view of John Connell's blacksmith shop on Pond Street. John Connell (far right) labored in general jobbing with a specialty in fine horseshoeing, with particular attention paid to interfering and ever-reaching horses.

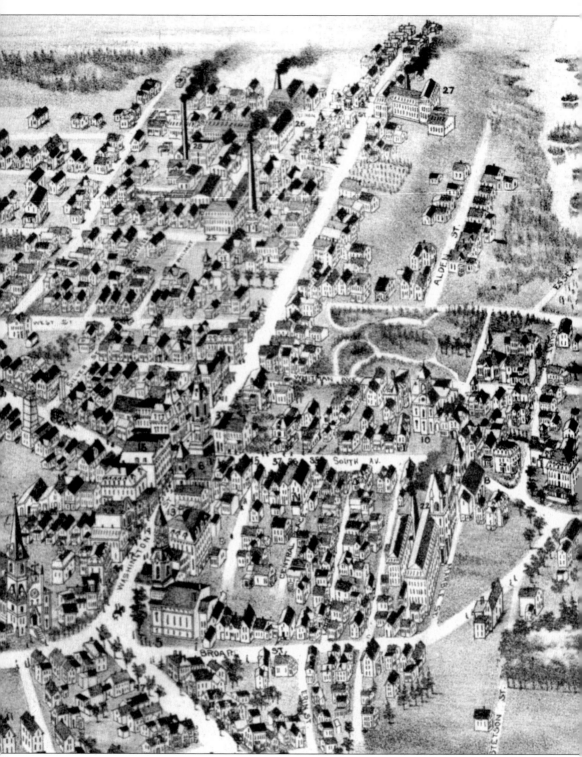

A BIRD'S-EYE SKETCH OF SOUTH ABINGTON, C. 1882. In this bird's-eye sketch drawn a few years after the town's incorporation, the smoke stacks of the factories, which became the

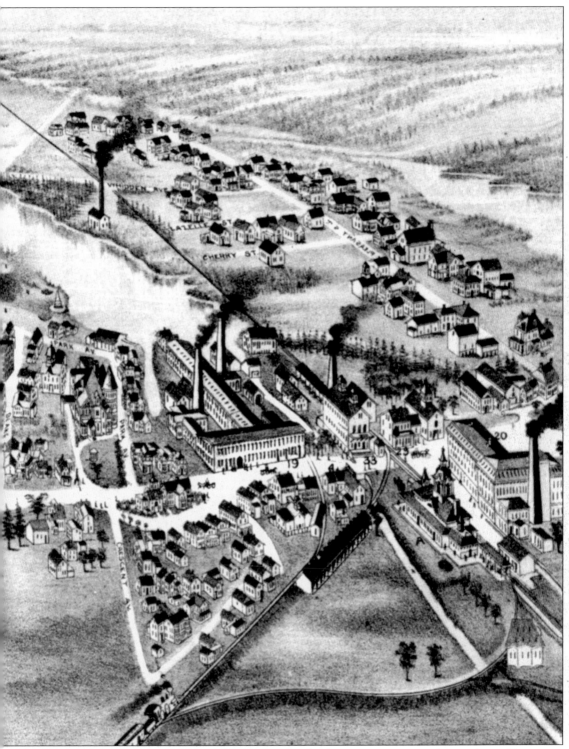

backbone of the town, tower towards the sky. In the bottom center are the tracks to East Bridgewater as they cross under the Washington Street railroad bridge.

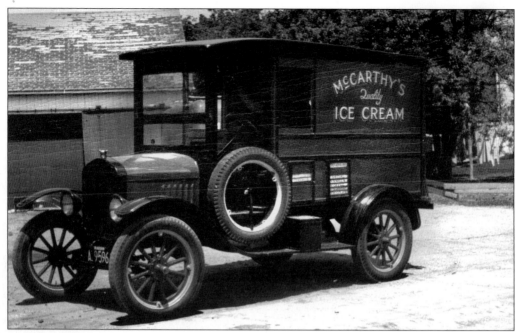

McCarthy's Ice-Cream Truck, c. the 1920s. The ice-cream manufacturer located on Commercial Street served southern New England throughout most of the 20th century. This company truck, often driven by "Jiggs" Donahue, was among the first of its kind in the area to cruise the streets of Whitman on hot summer days selling individual cold treats to customers of all ages.

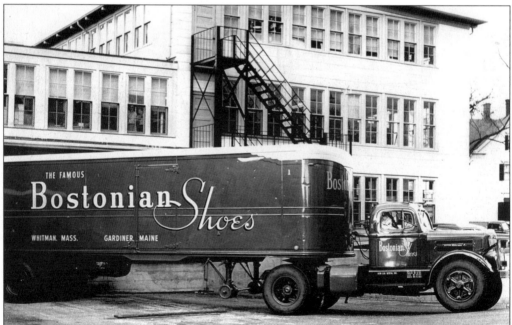

The Bostonian Shoe Truck. A company tractor trailer loaded up with a shipment of shoes c. 1965 prepares to embark from the loading dock on Broad Street to multiple locations throughout the area.

Four

PUBLIC BUILDINGS AND CIVIL SERVANTS

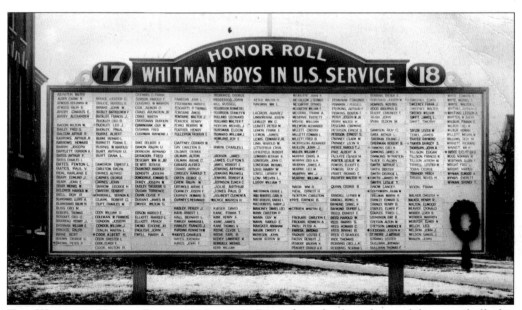

THE WHITMAN HONOR ROLL, 1917–1918. Erected on the front lawn of the town hall, this sign reflects the support and admiration of the brave men who served the town and country so bravely. This honor roll lists every local hero who served in World War I.

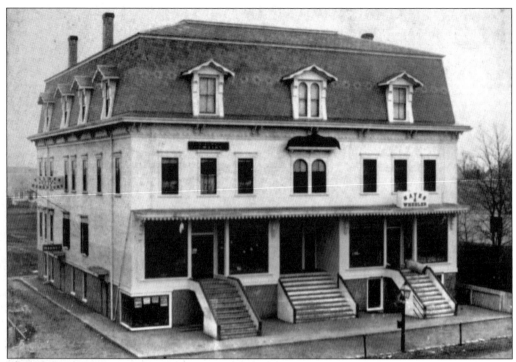

The Village Hall. Located on the southeast side of Washington Street, this building served as the original town hall for many years. In the infancy of the town, the hall served the town admirably. The building was destroyed in a 1910 fire. It stood where the public parking lot next to the Baptist church is today.

The Grand Army of the Republic Hall. Post 78 Grand Army of the Republic was formed by several members from Abington's post 73. Instituted on February 9, 1869, with 14 charter members, the charter bears the date January 30, 1869. The lot for the building on Hayden Avenue was purchased from A.H. Vining in 1891 for $600. The first meeting in the new G.A.R. hall was held on December 1, 1896, the day before the building's dedication.

THE ARMORY OF COMPANY E 4TH REGIMENT, MASSACHUSETTS VOLUNTEER MILITIA. When President Lincoln put out his call for volunteers on April 14, 1861, the first regiment in the Union to respond was our own Company E 4th Regiment. Led by Capt. Charles F. Allen, the company boarded the 7:00 a.m. train to Boston. Shortly after their arrival at Boston Common, the company marched through a nor'easter to city hall, where they were the first to sign in.

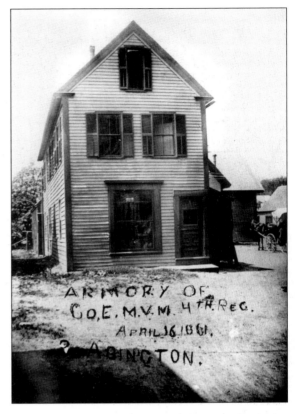

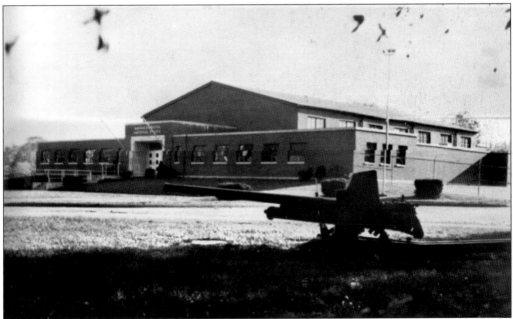

THE WHITMAN NATIONAL GUARD BUILDING. Located behind the Central Fire Station is the Whitman branch of the Massachusetts National Guard. The town has always had a proud tradition of military service. The National Guard building occupies the former site of Legion Field.

49

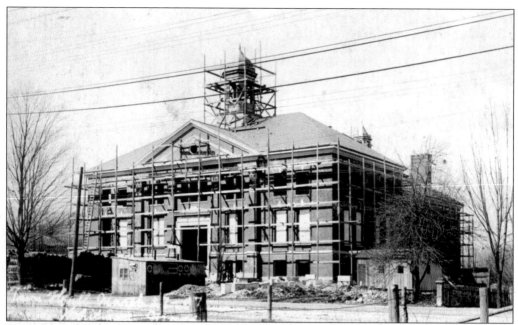

BUILDING THE TOWN HALL, 1906. At the time of its construction in 1906 and 1907, the residents of the town must have been awed by the town hall's immense presence. In addition to the operation of the town's business, this building has served the residents with many concerts and dances over the years.

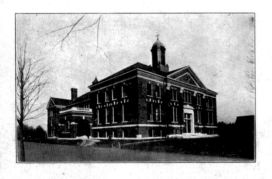

DEDICATORY

EXERCISES

OF THE

WHITMAN TOWN HALL

TUESDAY AFTERNOON

DECEMBER 10, 1907

THE TOWN HALL DEDICATION PROGRAM. On Tuesday, December 10, 1907, Whitman's newly constructed town hall was dedicated and opened for business. Within the walls of this stunning building all of the town's political business is done. At one time, the building housed the town library. Over the decades, many social activities have been staged in its ample auditorium.

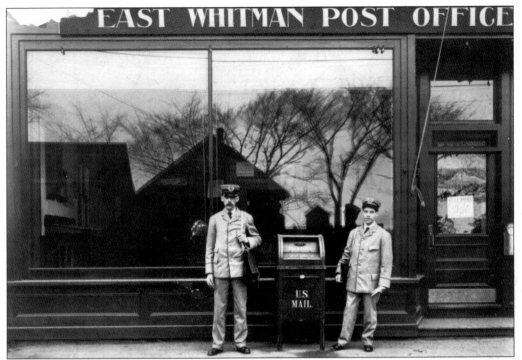

THE EAST WHITMAN POST OFFICE. In 1888, the east Whitman post office was established with Joseph Pettee as postmaster. The first mail carriers were put into service on May 1, 1907, with Frank A. Coleman and Lantz Osborne servicing the east side of town. On January 1, 1908, the uptown post office followed suit, putting carriers John Cody and Walter Prouty on the streets. In 1917, the town's two post offices were consolidated and moved to a location in the Freeman Block on South Avenue.

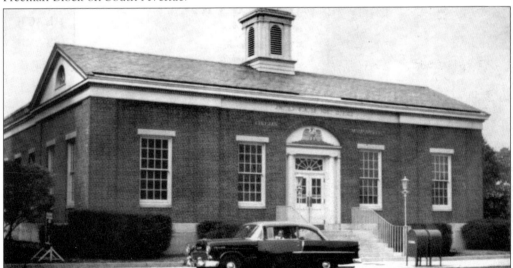

THE WHITMAN POST OFFICE. Throughout the years, small post offices have been in many locations in the town. In 1938, a new post office was built on South Avenue near the central part of town to consolidate the community's postal needs. This building, pictured here in the 1950s, has adequately served the residents for the past 65 years.

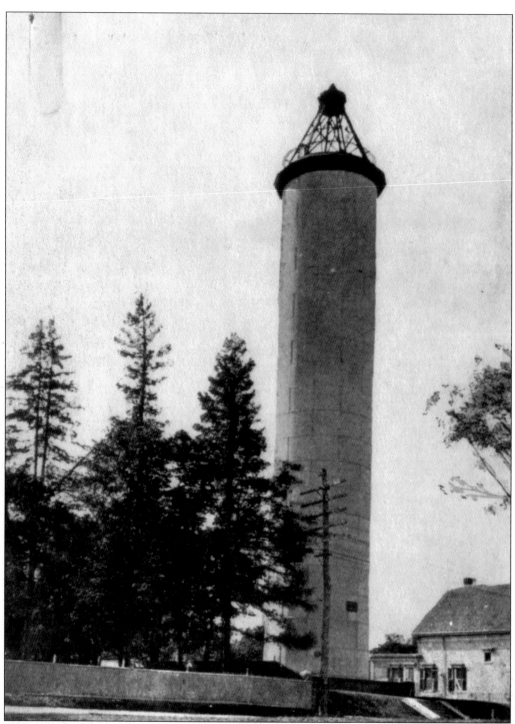

THE WATER TOWER, TEMPLE STREET. Standing 105 feet tall and 20 feet in diameter, the huge standpipe was situated near the center of the settled part of town on Temple Street. From atop its observation deck, local surveyors would measure their triangulations as they established boundaries of nearby towns.

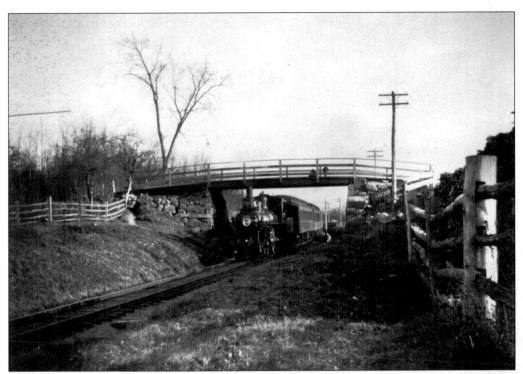

THE SPUR LINE TO EAST BRIDGEWATER. Starting at the east end train depot, the spur line crossed over the Schumatuscacant River, passed behind the homes on Commercial Street, crossed under Washington Street, and traveled over Auburn Street. On its way to East Bridgewater, it would stop at the Washington Street depot, which was located on the site of the current Larry's Laundromat.

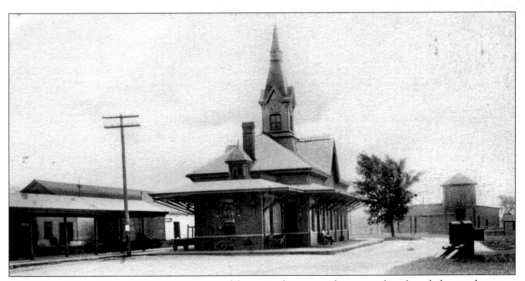

THE EAST END TRAIN DEPOT. Pictured here is the second east end railroad depot that was built to replace the original station that had burned. Unfortunately, history repeated itself, as this new building also fell victim to fire on November 23, 1972.

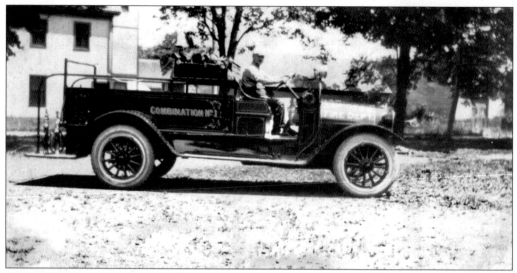

An EARLY COMBINATION FIRE TRUCK. Throughout the years, the Whitman Fire Department has continuously upgraded its equipment to ensure the safety of the town's residents. Pictured here is an early new fire truck that has been put into service.

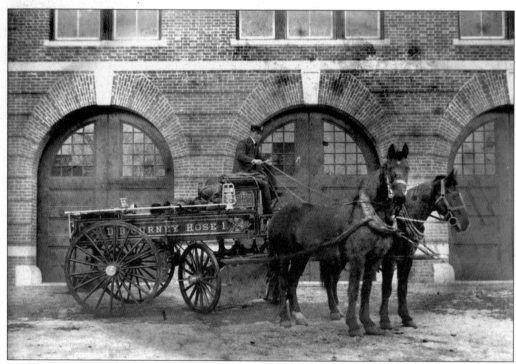

THE D.B. GURNEY HOSE NO. 1 WAGON. Driven by Charles Conant, the D.B. Gurney Hose No. 1 wagon could respond to all parts of the town from its Temple Street location. Pictured here in front of the Central Fire Station in the early 1900s, this state-of-the-art machine must have made the citizens of the town feel much more secure.

54

FIRE CHIEF LAWRENCE W. PHILLIPS.
Chief Phillips began his career as a call
firefighter in 1919 and was promoted to
captain in 1944. After his promotion to
chief in 1949, he oversaw a revolution in
technology as firefighting equipment
became much more effective and efficient.

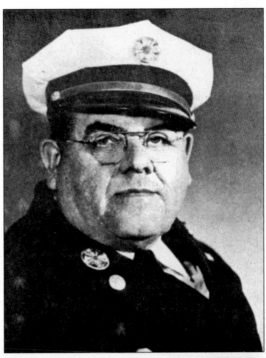

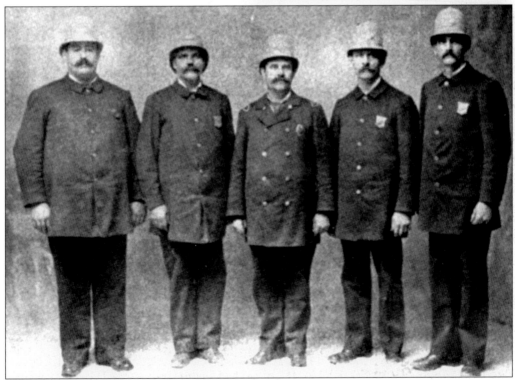

WHITMAN'S FIRST POLICE FORCE. In this April 1, 1896 photograph is the first organized
Whitman police force with a recognized chief. Present and ready for duty are, from left to right,
A.R. McCallum, William H. Churchill, Chief P.H. Smith, F.J. Rand, and H.H. Bliss.

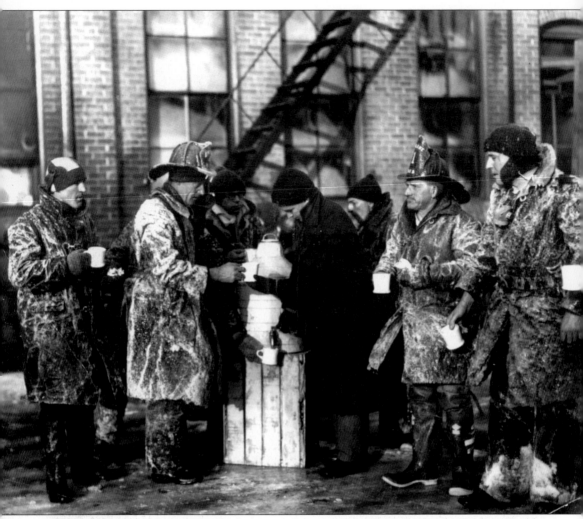

THE JENKINS BUILDING FIRE, FEBRUARY 1930. On February 6, 1930, the Jenkins Building, located on Washington Street between Whitman and South Avenues, burned for the third time in 25 years. The fire was fought for 19 hours in bitter-cold temperatures by firefighters from many towns. In this photograph, the firemen are being served hot coffee during a well-deserved break.

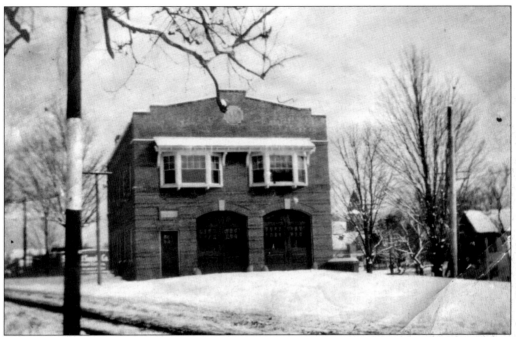

THE EAST END FIRE STATION. On March 5, 1906, the town voted to appropriate $12,000 to purchase a plot at South Avenue and Pleasant Street and erect a fire station. The fire station still stands and currently houses an insurance company.

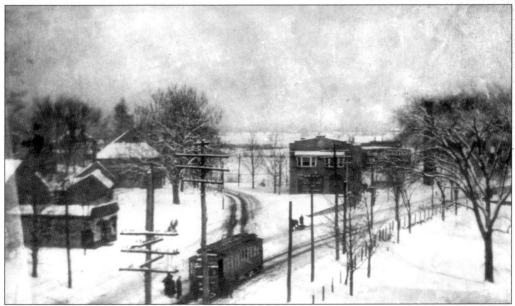

A TROLLEY, THE EAST END, C. 1910. In this winter scene, the trolley stops in the east end to pick up passengers on its way to Hanson. This photograph was taken from the Regal Shoe Company building. The intersection at the east end fire station has remained remarkably unchanged to this day.

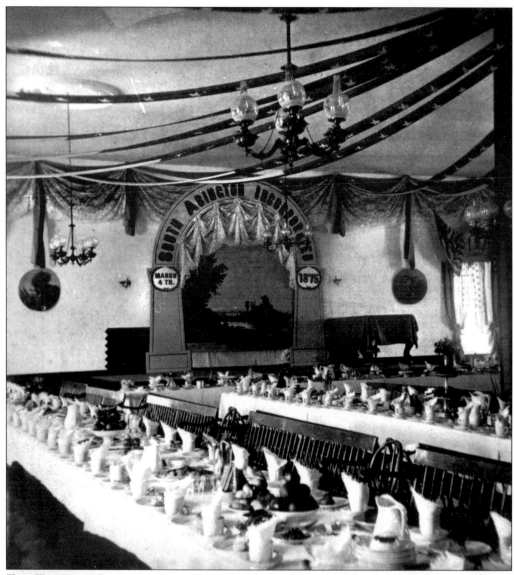

THE TOWNSHIP INCORPORATION DINNER, MARCH 4, 1875. On this day, the new town of South Abington was incorporated. The name was changed a mere 11 years later to Whitman, after the townsfolk selected the name in a popular vote. Having a population of only 2,456 at the time, it can be assumed that the celebration dinner at the village hall was attended by a majority of the adult residents.

Five

SCHOOLS

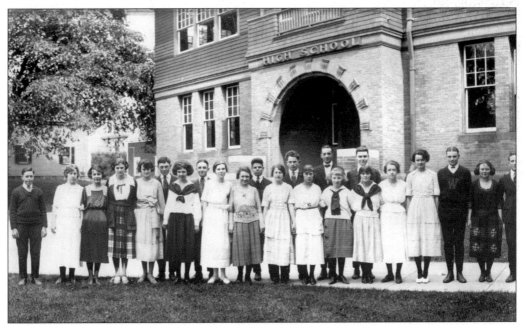

THE WHITMAN HIGH SCHOOL CLASS OF 1921. Pictured here are some of the Whitman High School Class of 1921 graduates posing in front of the South Avenue high school. The high school was renovated in 1912 in order to serve the town for another 25 years. Unfortunately, the town's population grew too fast, and the school was only adequate for another 15 years, when the new Essex Street high school was constructed.

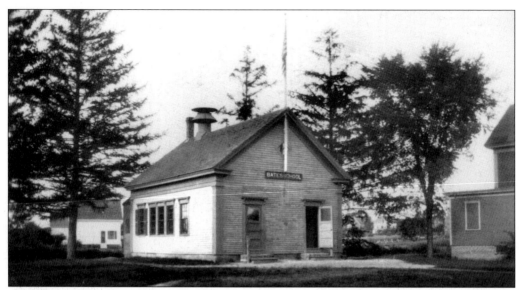

THE BATES SCHOOL. Originally known as the Auburnville School, which serviced the Auburnville section of town, this school became the Bates School in 1898. Located on the northeast corner of the intersection of Auburn and Bedford Streets, it was renamed to honor the Bates family who lived nearby. This family served the town in a variety of capacities. One member was a selectman, one was a librarian, and others served in the military. The school closed in the fall of 1914, after the school's enrollment had dwindled to about 20 students in grades one through three. The students were relocated to the Dyer School and used trolley transportation, paid for by the school department, to make the trip.

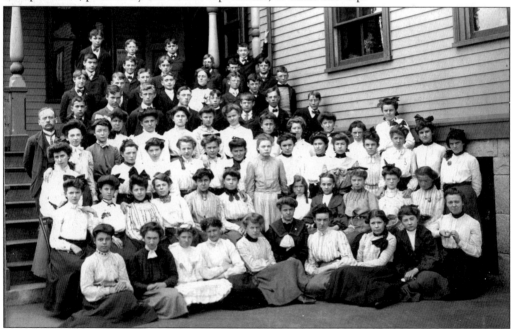

UNKNOWN SCHOOL KIDS. In this turn-of-the-century photograph, students from one of the town's many schools sit on the front steps to pose for a class picture. Judging from the lack of smiles, students must have felt the same way about school then as they do today.

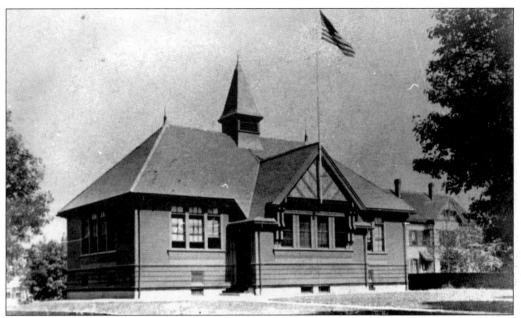

THE ORIGINAL CORTHELL SCHOOL, WHITMAN AVENUE. Built *c*. 1887 on Whitman Avenue, the original Corthell School burned to the ground in 1906. The school was replaced by a new larger school. This later Corthell School is still standing and eventually became the administration offices for the school district. The current Whitman Head Start program operates from this location today.

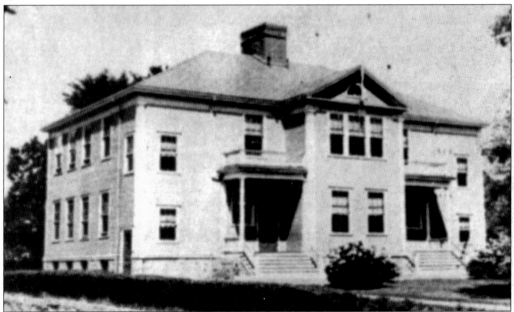

THE NEW CORTHELL SCHOOL. Built as a replacement for the old Corthell School that burned on February 8, 1908, this new Corthell School opened its doors just eight months later, on October 3, 1908. Immediately after the fire, a special town meeting was held and $14,500 was approved for the construction of the new school. After 45 years in use, the new school was converted to the offices for the school department.

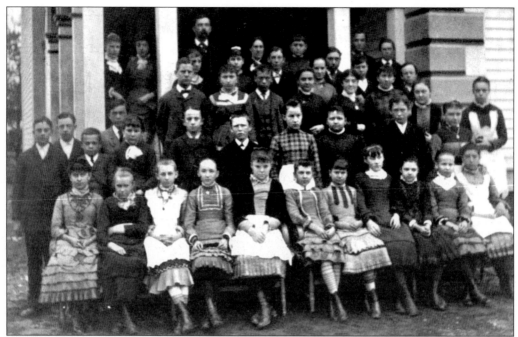

HASTINGS JUNIOR HIGH SCHOOL STUDENTS, PRIOR TO 1896. In this 1890s photograph, students from the Hastings junior high school pose for a class picture. By this time, the former high school had no doubt seen many fine students pass through its doors.

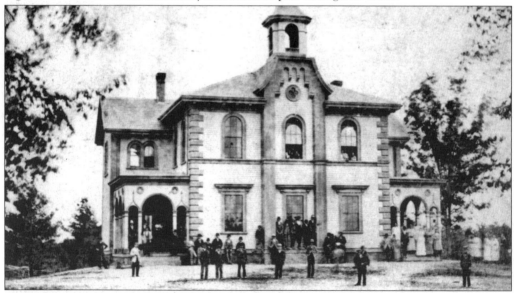

THE HASTINGS SCHOOL. In 1870, $12,000 was appropriated for a new high school to be built on South Avenue. The original wood structure was moved to the corner of Alden Street and Robert Avenue c. 1892, and a new brick high school was built in its place. The original high school then became known as the Alden Street School before the name was changed again in 1898 to the Hastings School. This change was in honor of Dr. Benjamin F. Hastings, a longtime school committee member. This four-room schoolhouse was attended by 196 pupils in grades four through eight. The school closed in 1927, and the building was torn down in 1932.

THE GURNEY SCHOOL, WARREN AVENUE. The original Warren Avenue school was a two-story structure that was moved and became a two-story home at 145 Alden Street. A more modern school was built to replace it c. 1897. A year later, the new Warren Avenue school was renamed the Gurney School. Over 100 years later, this school continues to serve as an educational institution as Mary-Deb Preschool.

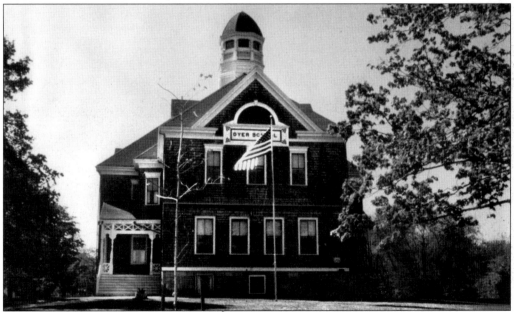

THE DYER SCHOOL. Located on the corner of School and Webster Streets, the site of the current library, the Dyer School building was destroyed by fire on August 25, 1983. Originally known as the School Street School, it was renamed the Dyer School in 1898 to honor a prominent local family. Built in 1888, the stunning new school was unveiled to the public with an open house on January 20, 1889. It was enlarged from 1905 to 1906. At one time, the town lock-up was in this building.

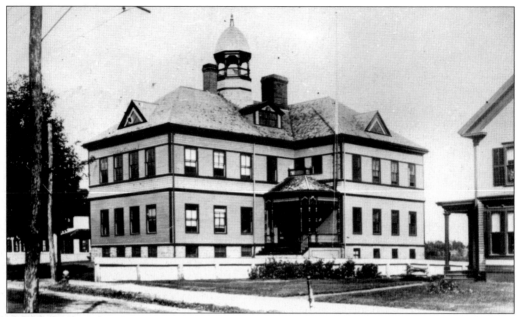

THE REED SCHOOL, PLEASANT STREET. The former Pleasant Street school, which was built in 1892, was renamed the Reed School in 1898. The school was declared surplus in 1954 after three new elementary schools were erected in the town. In 1972, the old school was razed and a home was built on the site at 81 Pleasant Street. A slate blackboard was relocated from the school to the Dyer School with a plaque that read, "Blackboard from Reed School, Built 1892; Razed 1972; Installed on Blackboard Frame."

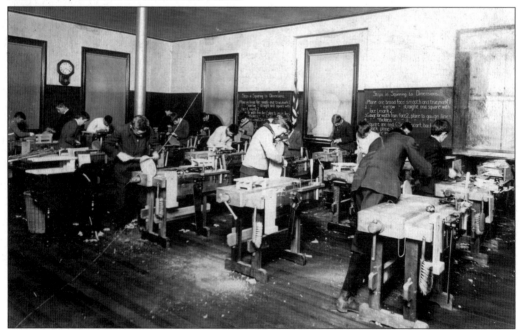

THE WHITMAN HIGH SCHOOL WOOD SHOP. The high school kids in this *c.* 1900 photograph seem a bit overdressed for shop class. The students are busy at work on their class projects and are trying to get things just right.

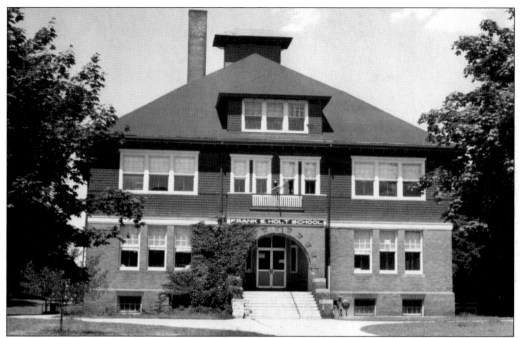

THE FRANK E. HOLT ELEMENTARY SCHOOL, SOUTH AVENUE. The original wooden high school was relocated to the corner of Alden Street and Robert Avenue *c.* 1892 and replaced with a new brick high school. This building served as a high school until 1927, when it then became a junior high school. After its tenure as a junior high it served as the Frank E. Holt Elementary School. The attractive building still stands in its original location and has been converted into the Holt Park Place luxury condominiums.

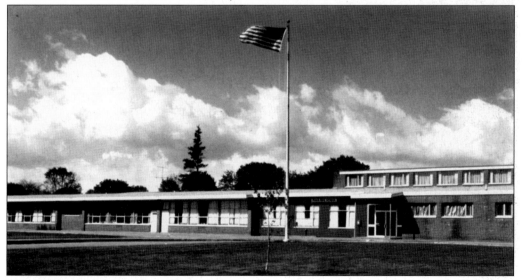

THE PARK AVENUE SCHOOL, PARK AVENUE. This school was built in 1953 on the former site of the Whidden mansion. The original stone wall that marked the property boundary still stands on South Avenue. The school continued to serve as an elementary school for kindergartners as late as 2001 and recently operated pre-kindergarten programs for many younger children.

THE LOUISE A. CONLEY ELEMENTARY SCHOOL, FOREST STREET. After being known for many years as the Forest Street School, the school was renamed the Louise A. Conley School to honor principal Louise Conley. Built in 1953, the school went through a major reconstruction in the late 1990s and continues to operate as one of the two elementary schools in town offering kindergarten through fifth grade.

THE JOHN H. DUVAL JR. ELEMENTARY SCHOOL, REGAL STREET. Located in the east end of town, the John H. Duval Jr. Elementary School has provided elementary education to students for many decades. Previously known as the Regal Park School, it was renamed in honor of a longtime local prominent businessman. A complete restoration project of the school within the past few years has improved the building so much that it will remain functional for many more decades.

THE WEST MIDDLE SCHOOL, CORTHELL AVENUE. Pictured here in 1979, the West Middle School was built to service the increasing numbers of middle school students in the town. After East Middle School was converted into an elementary school in the 1980s, the West Middle School was changed to the Whitman Middle School and continues to serve grades six to eight in the new millennium.

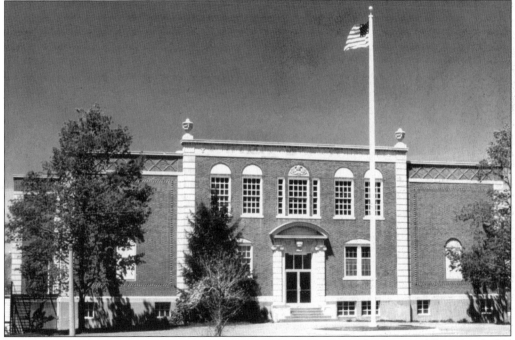

THE EAST MIDDLE SCHOOL, ESSEX STREET. Seen here in 1979 as the East Middle School, this building may have served the children of Whitman in more capacities than any other. Built in 1927 to replace the outdated South Avenue high school, the new spacious building seemed state-of- the-art at the time. It served as a high school until 1960, when the Whitman-Hanson Regional High School was constructed. It was then converted to a junior high school and served in that capacity until becoming an elementary school in 1982.

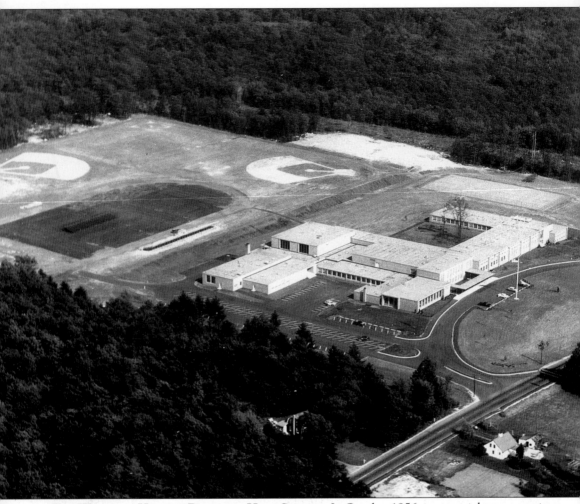

THE WHITMAN-HANSON REGIONAL HIGH SCHOOL. In October 1956, in a special town meeting, Whitman residents voted to combine the high school with Hanson to provide a bigger and better facility for both towns. In 1958, bonds were issues for a total of $1,997,000, and work began in August of that year. When excavation started, a makeshift cemetery called the Smallpox Cemetery was uncovered. Hastily created in the 1770s when four or five victims were buried there, all but one of the bodies were subsequently moved by the victims families. The only remaining soul was Amos Whitmarsh, who died on January 8, 1778. After the marker and remains were relocated to the Mount Zion Cemetery on Washington Street, the work was resumed.

Six

HOUSES OF WORSHIP

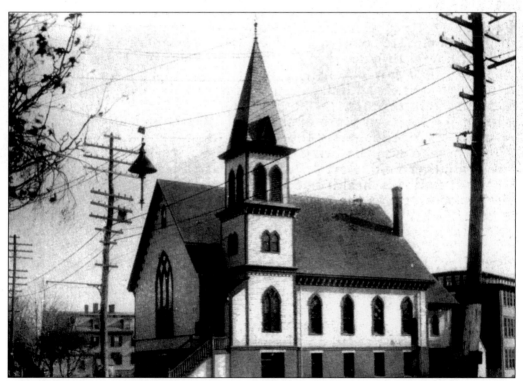

THE UNITARIAN CHURCH, THE CORNER OF MARBLE STREET AND SOUTH AVENUE. Interest in the Unitarian religion in the town began in the 1880s, when ministers from nearby towns would preach at the Grand Army Hall. After a petition was signed by 78 people in 1886, the First Unitarian Society of Whitman was formed. The church is currently occupied by the Time Out Sports Company.

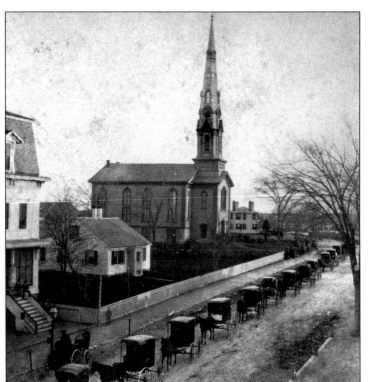

MINISTER THOMPSON'S FUNERAL PROCESSION, 1876. Pictured here is the funeral procession for the minister John Thompson. In addition to the carriages that line Washington Street, the village hall can be seen in the front left, while the Congregational church towers in the background.

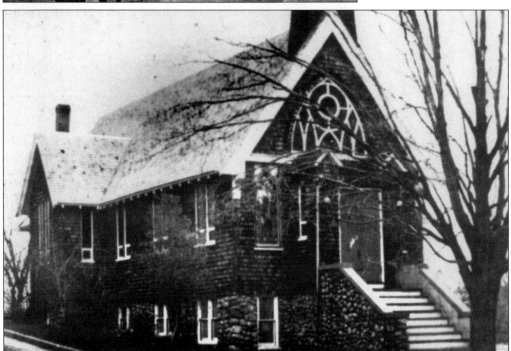

THE ALL SAINTS EPISCOPAL CHURCH. Five years after the purchase of a parcel of land on Park Avenue, the All Saints Episcopal Church building was dedicated on December 30, 1910. In 1952, after more than 50 years as a mission, All Saints became a parish.

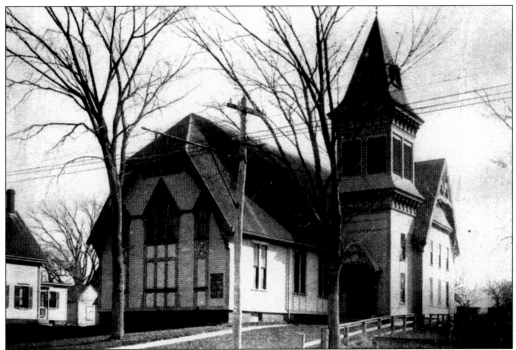

THE METHODIST EPISCOPAL CHURCH, SOUTH AVENUE. The Methodist Episcopal Church grew out of a prayer meeting on December 31, 1873, in the offices of H.H. Brigham, who opened the meeting by reading scripture and offering prayers. A finance committee was selected "with authority to manage all business connected with Methodist preaching in Union Hall for the Year." The first preaching service was held on Sunday, January 4, 1874, with Rev. G.H. Gregory of the Boston School of Theology. On July 27, 1876, ground was broken, and the completed building was dedicated on February 24, 1877. It is apparent in these two photographs that the original wood structure has been completely reconstructed.

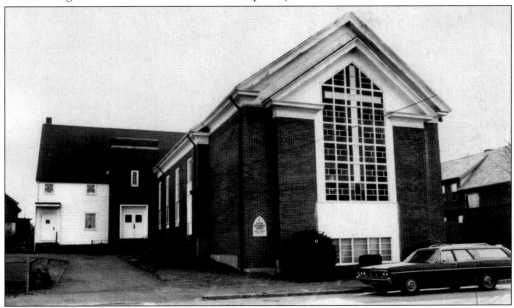

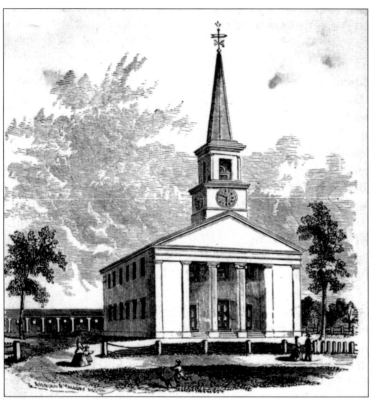

THE FIRST CONGREGATIONAL CHURCH, THE CORNER OF WASHINGTON AND BROAD STREETS. On November 4, 1806, it was voted to accept a land offer by Ebenezer Porter for a three-quarter-acre lot on the corner of Washington and Broad Streets. At the same meeting, it was voted to construct a meetinghouse on the site. On August 19, 1807, the Second Church of Abington (top) was opened at a cost of $6,500. After many attempts to block it, the parish was incorporated in February 1908 as the Union Calvinistic Society in the southerly part of Abington. On April 11, 1911, the church itself was incorporated as the First Congregational Church of Whitman (bottom). The preacher's yearly salary was set at $400. A bell was purchased at a cost of $450 dollars. Sunday school opened on the first Sabbath of 1819. In January 1843, the ladies sewing circle was organized. In 1844, the church took an open and, at the time, highly unpopular stand on slavery. It was recorded, "that we will use all lawful means in the spirit of meekness and forbearance but with faith and energy for the immediate abolition of slavery."

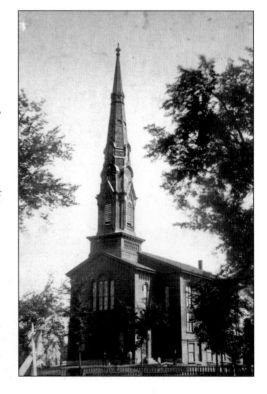

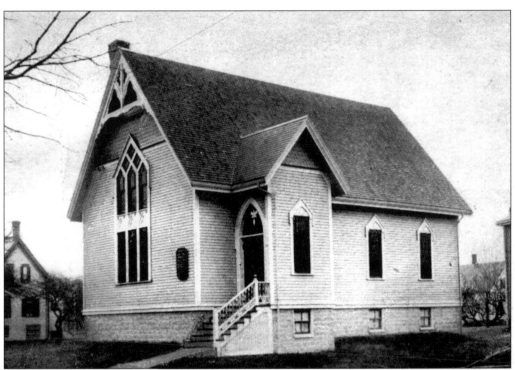

THE ADVENT CHRISTIAN CHURCH, WEST STREET. In 1884, the deacon W.E.H. Vaughan and his wife began holding cottage prayer meetings. A few years later, on May 9, 1888, the Advent Christian Church was organized with 10 charter members. In April 1893, during an era of prosperity for the church, land was purchased and a building was erected. After being incorporated on October 30, 1893, the first services were held on May 13, 1894.

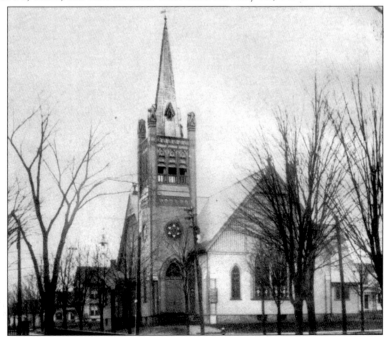

THE BETHANY FREE BAPTIST CHURCH, THE CORNER OF WASHINGTON AND WEST STREETS. Incorporated in June 1890, the Bethany Free Baptist Church opened its doors on January 24, 1894. The church had roughly 100 parishioners *c.* 1900. Local businessman O.H. Ellis served as the first deacon and treasurer. The church, which was razed, was located on the site of today's Mike's Automotive.

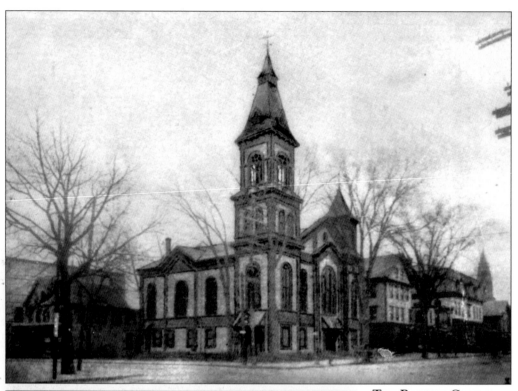

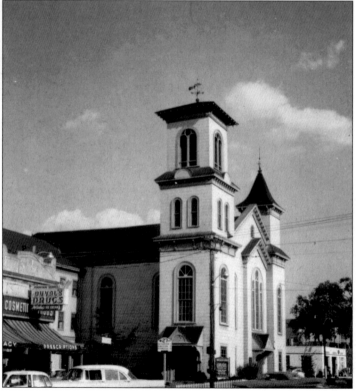

THE BAPTIST CHURCH, THE CORNER OF WASHINGTON STREET AND SOUTH AVENUE. The first Baptist Church of Abington was constituted in South Abington on October 30, 1822, with the following people in attendance: Josiah C. Ransford, Jonathan R. Gurney, Robert Cook, Nathan Alden, Thaxter Reed, William Packard, Sarah Ransford, Allan Dunbar, Molly Gurney, Mary Hobart, and Deborah Gurney. The church is seen here in two different eras. The outline of the original structure (top) remains apparent in the current version.

THE CHURCH OF THE HOLY GHOST, SCHOOL STREET. After many years of traveling to Abington for Sunday services, on March 10, 1878, several men met to take action about buying land for a local church. In April 1878, the land was acquired for $447. In the spring of 1880, ground was broken, and work on the new church commenced. In December of that year, the first services at the Holy Ghost church were held in the basement on Christmas Day. The upper church was completed six years later, and on November 14, 1886, it was dedicated. The original wooden structure pictured here (right) was replaced by the current brick house of worship (below) in 1922.

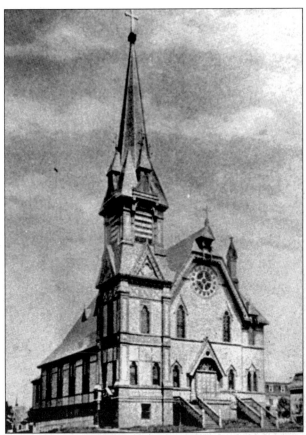

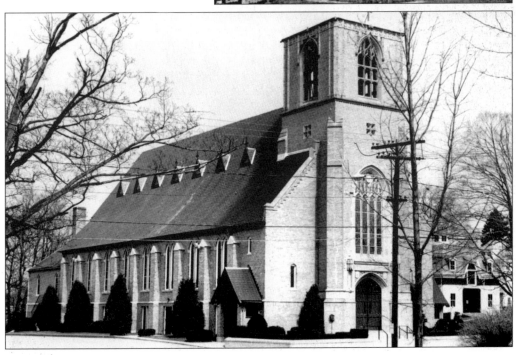

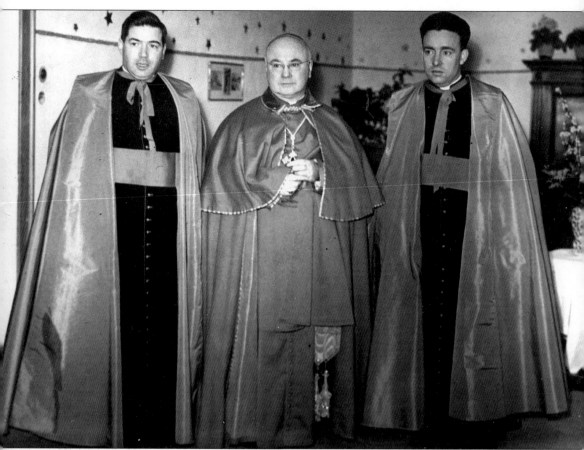

CARDINAL SPELLMAN. Francis Joseph Spellman was born in a small house on Temple Street on May 4, 1889. He was ordained on May 14, 1916, and he celebrated his first Mass at the Basilica of St. Peter. He became the first American attaché in the office of the Vatican secretary of state and served as the official English translator for Pope Pius XI. On February 21, 1946, he became a cardinal. Later, he built a residence at 760 Washington Street that was modeled after a Rome villa.

Seven

SPORTS AND
RECREATION

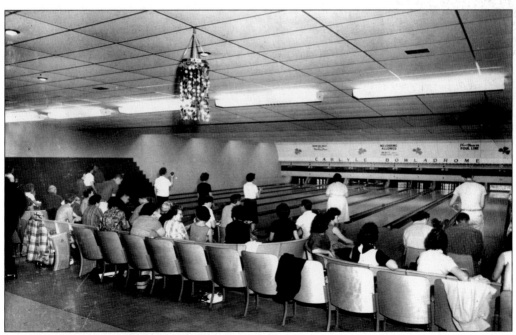

CARLYLE BOWLADROME, THE EARLY 1960S. The South Avenue bowling alley that was located in the east end of town was a popular recreation spot for candlepin bowlers of all ages. For many decades, the Carlyle was a mainstay in the town until it was destroyed by fire in the mid-1990s.

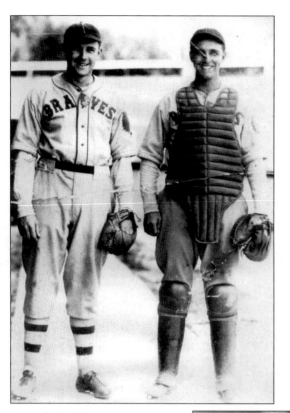

WHITMAN CATCHER JOHNNIE BENSON. Benson is pictured here in 1932 with Bobby Brown, a former high school rival. After competing against each other in high school, Benson and the former Hingham high school star Brown played together for the Braves in 1932. Brown compiled a record of 14 wins and 7 losses for Boston that season.

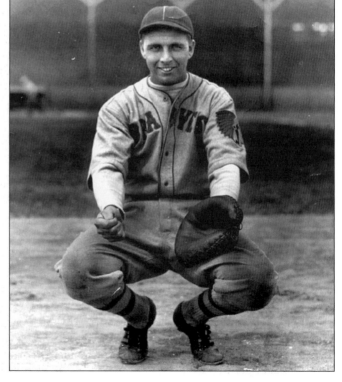

JOHNNIE BENSON OF THE BOSTON BRAVES. The 1928 graduate of Whitman High School reached the pinnacle of his baseball career serving as the Braves bullpen catcher in 1932. He appeared in a spring training game against the New York Yankees that year and hit a single that was fielded by Babe Ruth. When he reached first base, the great Lou Gehrig shook his hand and said "way to go kid."

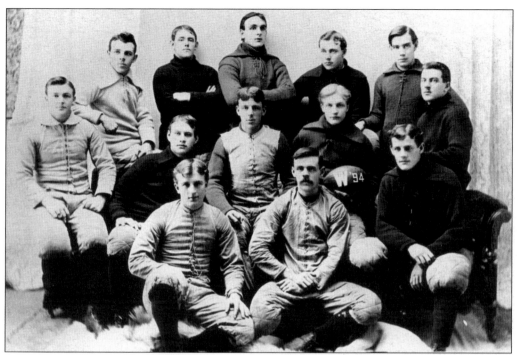

THE WHITMAN TOWN FOOTBALL TEAM, 1894. Sports have always been important to the history of the town. Pictured here is the 1894 Whitman town football team, who appear to be a pretty rough bunch.

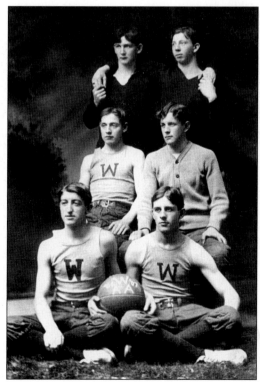

THE WHITMAN BASKETBALL TEAM, 1906–1907. Pictured here is the first Whitman basketball team in its 1906–1907 team photograph. With only six players on the team, no one would have to complain about a lack of playing time.

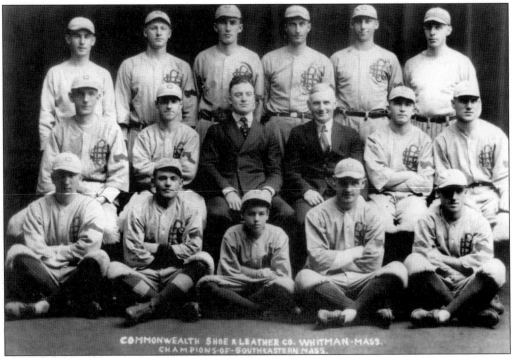

THE COMMONWEALTH SHOE AND LEATHER COMPANY 1919 BASEBALL TEAM. The same year the Chicago White Sox brought shame to that city by throwing the World Series, the Commonwealth Shoe and Leather Company baseball team proudly represented Whitman as they captured the southeastern Massachusetts championship. Many players from this extremely competitive league would go onto play professional baseball.

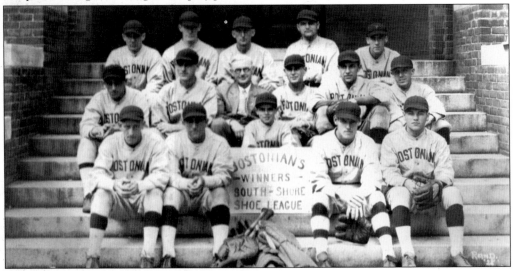

THE SOUTH SHORE SHOE LEAGUE CHAMPIONS, 1928. In the early part of the 20th century, the local shoe league baseball teams provided an excellent level of baseball. Many companies imported some of the best college players in the country to play on their company teams. Pictured here are the 1928 South Shore Shoe League champions, the Bostonians, representing the Commonwealth Shoe and Leather Company.

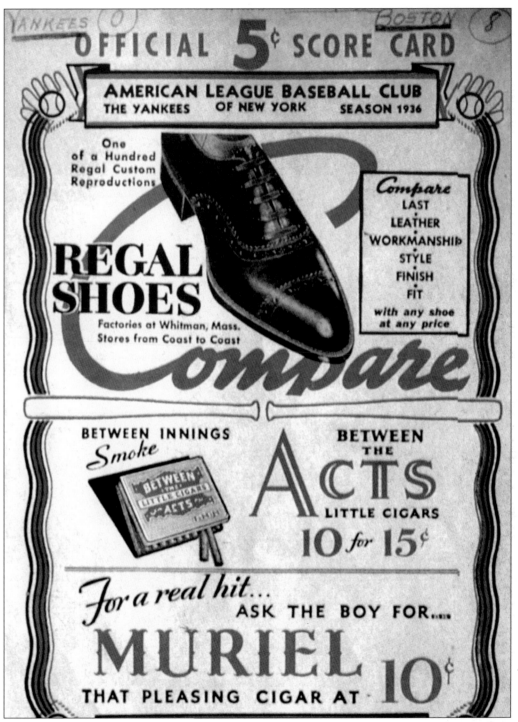

A Regal Shoe Advertisement. This Regal Shoe Company advertisement exemplifies how the town of Whitman received exposure in the big city of New York. An advertisement for the nationally known shoe manufacturer appeared on the scorecard of the 1936 world champion New York Yankees baseball team.

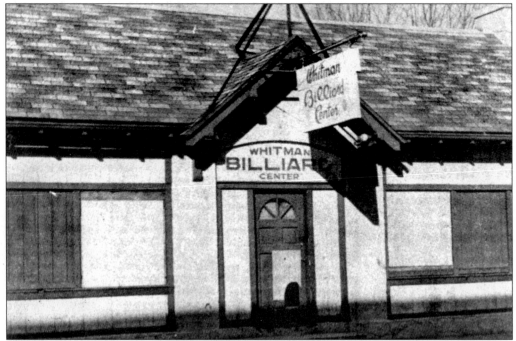

THE WHITMAN BILLIARD CENTER. Located across from Church Street on South Avenue, the Whitman Billiard Center was one of the focal points for entertainment in the town. This building also served as a post office and a furniture store and is now a parking lot next to Dunkin' Donuts.

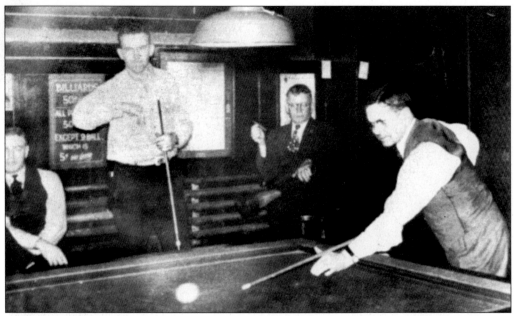

RACK 'EM UP! Seen here is a glimpse inside the Regal Bowling Alley and Pool Room, which was located on South Avenue. Pictured here are, from left to right, Leo Welch, selectman Richard Hayes, proprietor Herb French, and attorney John Geogan. Many referred to Geogan as "the wizard of the cue stick."

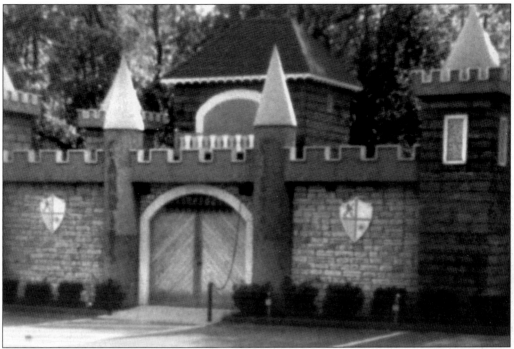

THE KING'S CASTLELAND ENTRANCE. The landmark on Bedford Street was a fairy tale-themed amusement park for children that was created in the late 1940s by World War II veteran Joe King. The park existed for 50 years until it was closed in the mid-1990s. Eventually, it was torn down and has been replaced by a Super Stop & Shop supermarket.

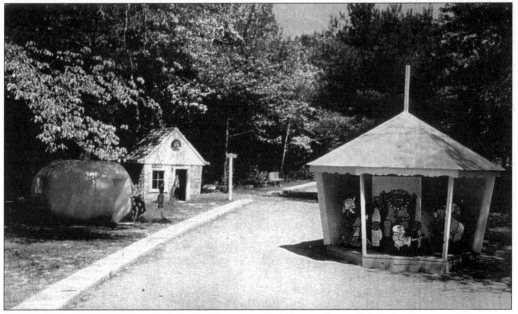

INSIDE KING'S CASTLELAND. Pictured here is a small sampling of the charming attractions in the children's amusement park. The tiny structure on the far left was a pumpkin house. On the far right, old King Cole sits upon his throne.

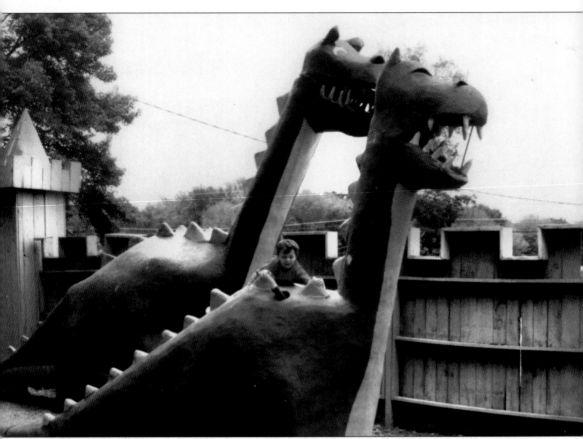

THE DRAGONS GUARDING THE CASTLE. The two imposing creatures were clearly visible from Bedford Street (Route 18). In addition to being mounted by an occasional park visitor, the pair stood just behind the front wall of King's Castleland and kept watch while the larger dinosaur on the left would occasionally breathe fire.

Eight

HISTORICAL MANSIONS AND HOUSES

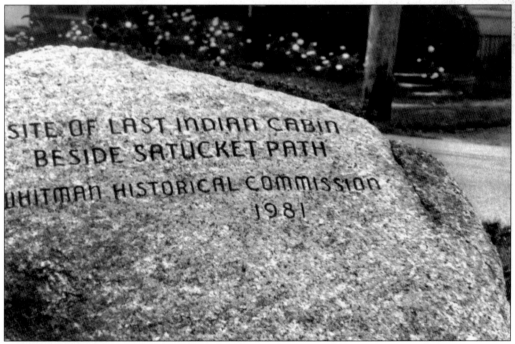

THE LAST NATIVE AMERICAN HOMESTEAD. In 1981, the Whitman Historical Commission placed an engraved stone marker at the corner of Commercial and Washington Streets. The large stone reads, "Site of Last Indian Cabin Beside Satucket Path."

THE MILLER COOK HOUSE. Located on the corner of South Avenue and Linden Street, the Miller Cook House still stands today. Prior to this house being erected, the house that occupied this lot was moved to 24 Linden Street.

THE HOSEA WHIDDEN ESTATE. Earlier houses on this historic spot were occupied by Joseph Josselyn, Col. Aaron Hobart, and Jonathan Reed. The house is currently occupied by the Park Avenue Elementary School. The stone wall seen in this photograph still stands to this day.

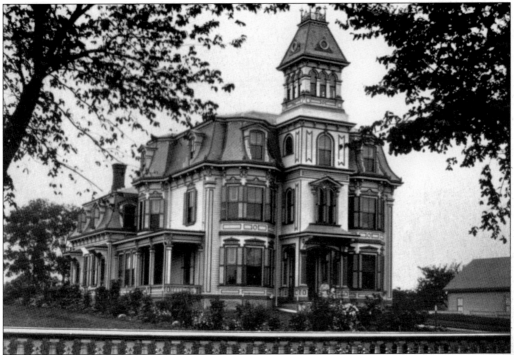

THE GURNEY VICTORIAN MANSION. Erected from fortunes made by manufacturing and selling tacks and nails, this beautiful mansion stood directly in front of the D.B. Gurney Tack Factory. The original curbings still line the sidewalks at this spot, although the house was razed due to its extremely costly upkeep.

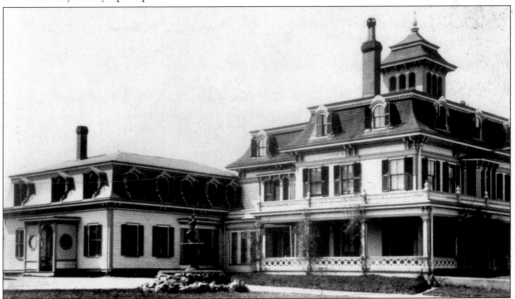

THE DAVID B. GURNEY HOUSE, WASHINGTON STREET. This house was located directly in front of the extant D.B. Gurney Tack Factory on Washington Street and was occupied by the company's owner. The huge kitchen wing seen on the left side of this photograph was relocated to Beulah Street, where it remains a single-family home.

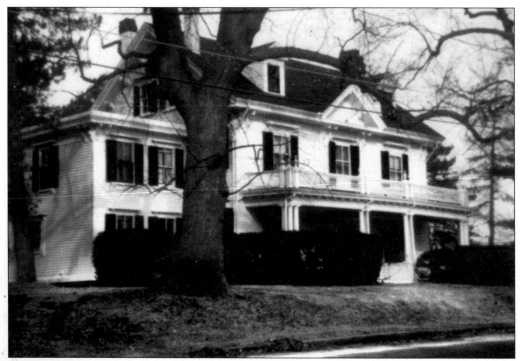

THE CHILDHOOD HOME OF CARDINAL SPELLMAN. Located on Beulah Street, this home is where young Francis Spellman grew up. Spellman's father was a successful local businessman in town and had his own business block. This block still stands and is the current home of Menard's Jewelers.

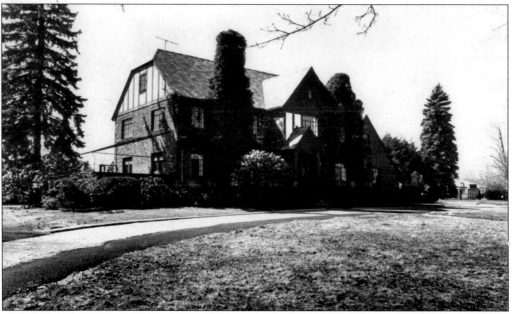

THE SPELLMAN HOME, WASHINGTON STREET. This stunning home was built by Card. Francis Spellman at 760 Washington Street across from the Mount Zion Cemetery. It was modeled after a Rome villa and is currently a operating as a funeral home.

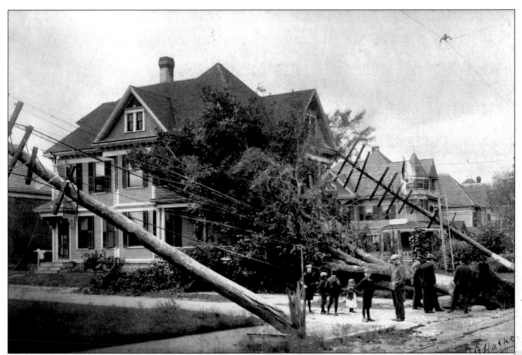

THE CHARLES DYER HOUSE. Judging from this picture, the homeowner, Charles Dyer, must have surely had better days. A gale storm on September 15, 1902, created this destruction in a matter of minutes. Two ox yolks were made from this fallen tree, and one of them is now part of the collection of the Dyer Memorial Library in Abington.

THE OLIVER GRANDON HEALY HOUSE. Located at 92 School Street, on the corner of Harvard Street, this house, which was erected in 1836, was owned by local builder Oliver Grandon Healy. Although the water pump in the middle of this intersection was removed long ago, the house still stands.

THE DAVID PORTER HOUSE. Built prior to 1730 by bachelor David Porter, the house that is located at 351 High Street is the oldest intact dwelling still standing in Whitman. Porter erected the house on land left to him by his father after his death.

THE REV. DANIEL THOMAS HOUSE. Located at 489 Washington Street the Rev. Daniel Thomas house was built from 1807 to 1810. Dr. Gad Hitchcock, the son of Rev. Gad Hitchcock, also lived here in the 1830s. This home was also known as the Bates house.

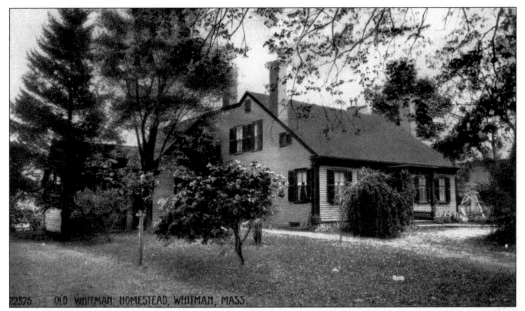

THE OLD WHITMAN HOMESTEAD. Built in 1825 by Augustus Whitman's father, Jared, the old Whitman homestead was located on the northeast side of Washington Street, near the center of town. The land that would eventually be donated for the town park was immediately east of this location. On the site where the home once stood, a bank has operated for many years.

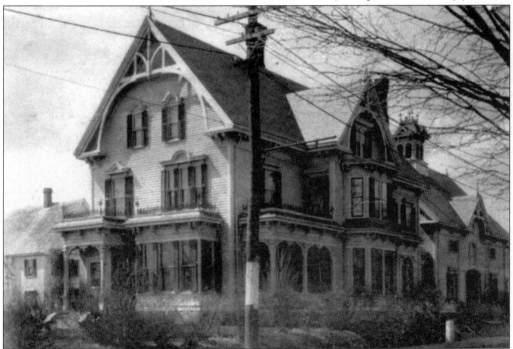

THE HIRAM JENKINS MANSION. This beautiful home once stood on the island between South Avenue and Old South Avenue. Owned by Hiram Jenkins, the site of this mansion is now the location of a Mobil gas station. The Hobart Bell Foundry marker is also located on its former grounds.

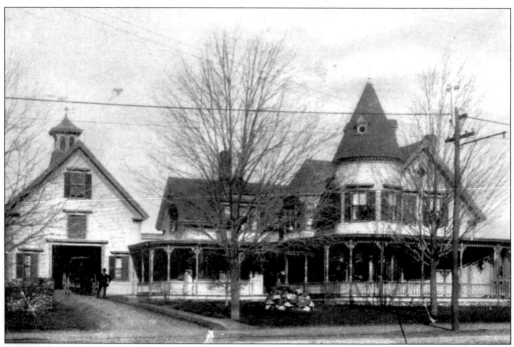

THE BENJAMIN ATWOOD ESTATE. Located at 163 Pleasant Street, this stunning home was owned by businessman Benjamin Atwood, who owned the Atwood Box Company. In later years, this home operated as a rest home and still stands today.

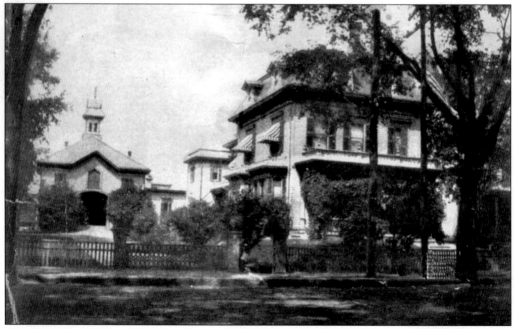

THE GEORGE A. REED ESTATE. Owned by local businessman George A. Reed, this home was built with the fortunes he made selling dry and fancy goods, hosiery, and corsets. Reed's store was located on the corner of Temple and Washington Streets in the same space Cavicchi's Market occupied for many years.

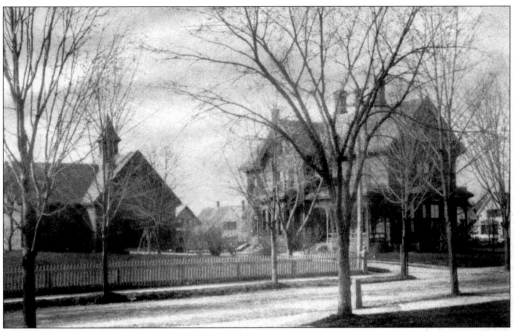

THE GEORGE O. JENKINS ESTATE. Along with his brother, Hiram, Jenkins owned the largest business block in Whitman Center, as well as owning companies in both Whitman and Bridgewater that produced leather board and caskets.

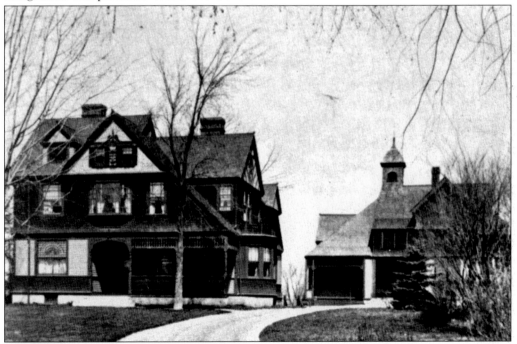

THE CLARENCE DURWOOD REED ESTATE. This attractive home was located on the north side of South Avenue, directly across from the Commonwealth Shoe and Leather Company. Reed was the superintendent of the huge Commonwealth factory that was of the largest of its type in the United States.

The Unusual Swain Estate. Located on Bedford Street, this unique house was relocated from England by the homeowner. Edward Swain had business interests in both Boston and New Bedford and located his homestead between the two locations. Also known as the gingerbread house, it was torn down due to disrepair and was later replaced by a Burger King.

The Maj. Marcus Reed Place. At the time of the town's incorporation as South Abington in 1875, this was home to George H. Pearson, the town clerk. Pearson conducted official town business from an office in the home set up for that purpose.

Nine

EVENTS AND
HAPPENINGS

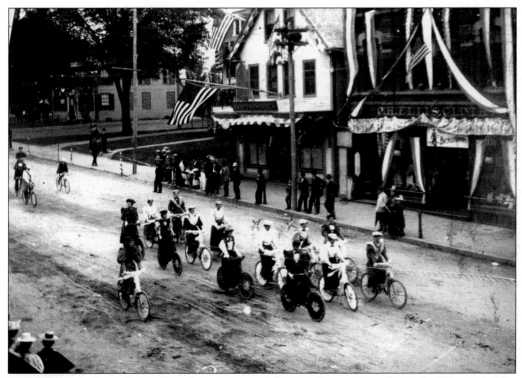

THE WOMEN'S BIKE CLUB. Seen here in one of the town's many parades is the Women's Bike Club. These fine ladies would wear their best outfits as they peddled proudly throughout the town.

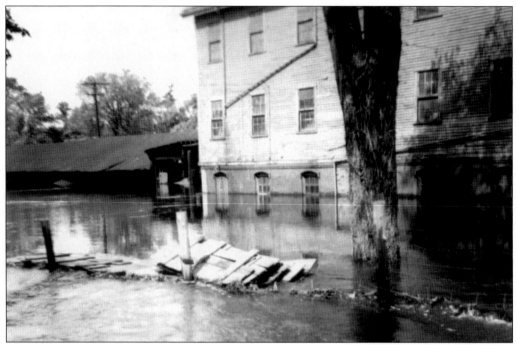

THE FEBRUARY 1886 FLOOD. In the winter of 1886, heavy snows followed by a rapid thaw caused a major flood in the east end of town. The flood was so serious that it spread to the higher uptown elevations. Local merchant Obed H. Ellis, who owned a clothes store uptown, sent men to Boston for rubber boots. After the men returned, the 250 pairs of boots they had acquired were sold out within an hour.

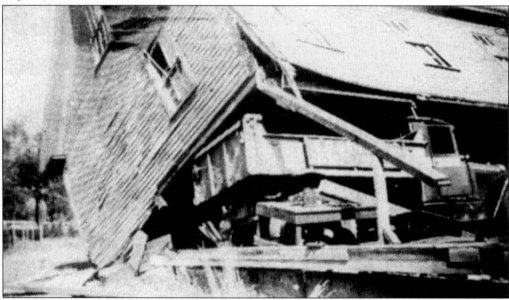

TROMBLY'S GARAGE. Whitman was not spared by the major hurricane that hit the region in 1938 and caused widespread devastation. Some of the tremendous damage the town experienced can be seen in this photograph of Trombly's Garage. It sits atop two trucks that were parked next to the building.

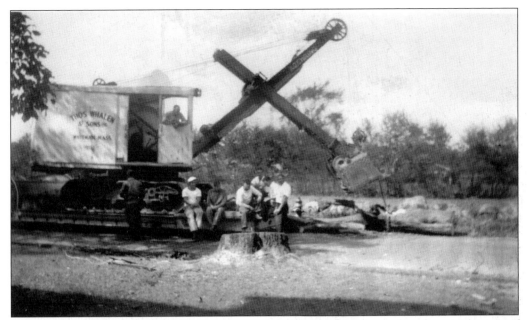

The 1938 Hurricane. In 1938, the town was struck by a hurricane that destroyed many of its largest trees. Pictured here is an early backhoe and crew as they take a well-deserved break from cleaning up the debris left behind by the natural disaster.

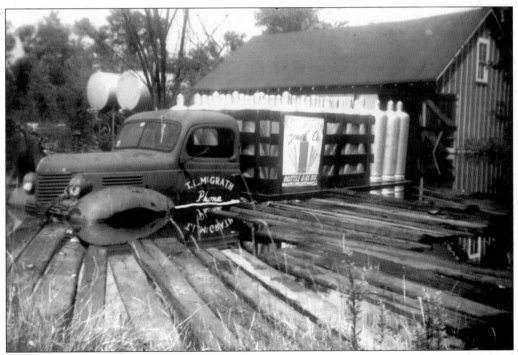

The East End Flood, 1955. In one of the many natural disasters in town history, this flood struck the east end in 1955. Pictured here is the T.L. McGrath delivery truck covered up to the top of its tires by the waist-high water.

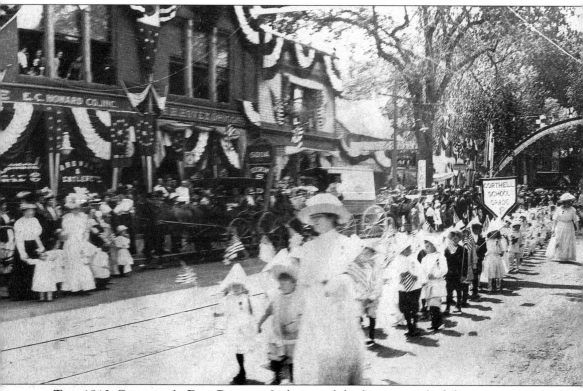

THE 1912 CHILDREN'S DAY PARADE. In honor of the bicentennial of the incorporation of Abington in 1712, the tri-town area of Abington, Rockland, and Whitman celebrated with huge parades. In the above photograph, the town's streets are lined with residents as students from the

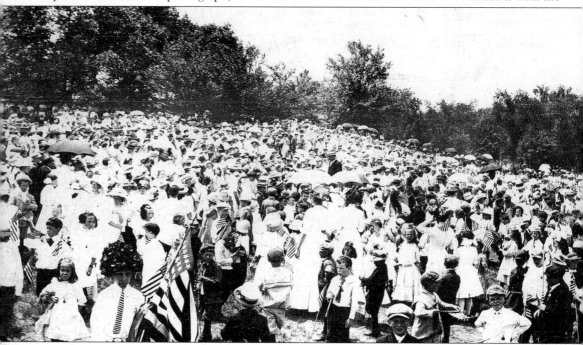

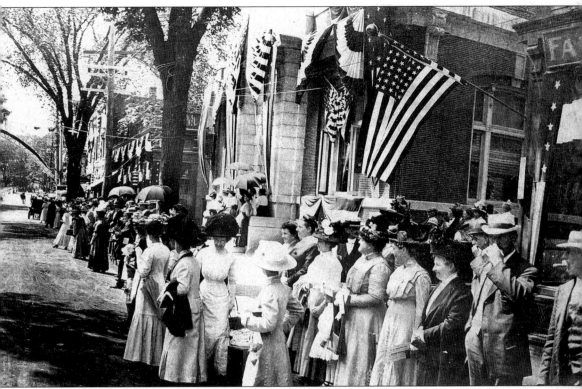

various schools in town proudly march through the streets. In the photograph below, the parade participants and observers have gathered at the town park to continue with the day's activities.

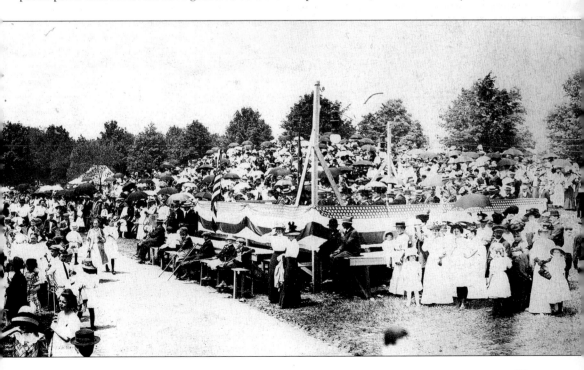

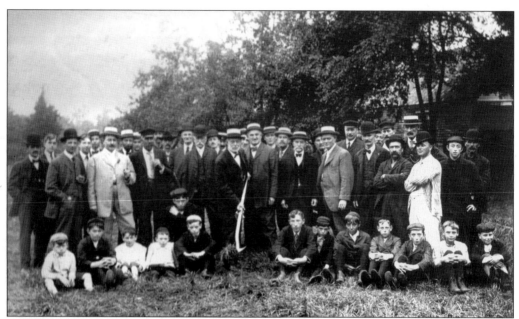

THE TOWN HALL GROUND BREAKING, AUGUST 2, 1906. Pictured here is a large gathering of the town's men and boys as the ground is broken to signal the beginning of construction for the new town hall. The new building quickly became a source of pride for the residents of the town. The building is still admired today.

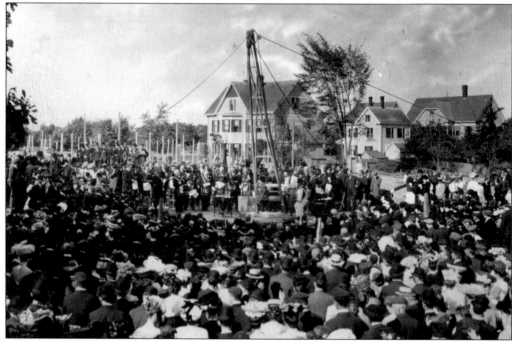

LAYING THE CORNERSTONE FOR THE NEW TOWN HALL, SEPTEMBER 29, 1906. A huge crowd gathered on this crisp fall day to witness the placing of the cornerstone for the new town hall. The engraved granite stone is located on the southwest corner of the building. The new town hall, which opened in 1907, continues to serve the town as it approaches its 100th birthday.

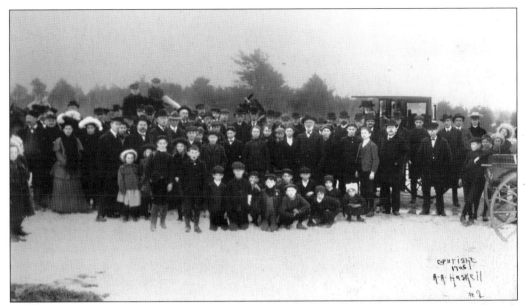

THE TOWN WATER FROM SILVER LAKE, 1905. In what was a huge milestone for the town, many of the town's men, women, and children are present as the public water supply from Silver Lake is turned on for the first time.

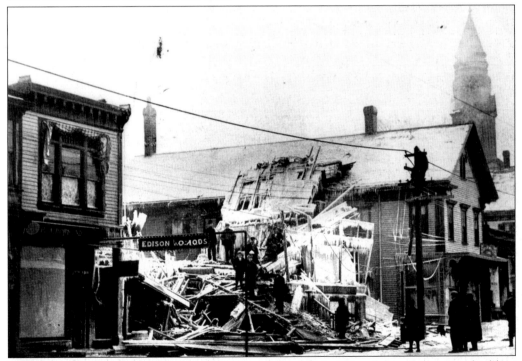

THE VILLAGE HALL FIRE, 1910. At one time, the village hall was the most imposing building in town. In 1910, the building burned to the ground in a spectacular fire. Many businesses were destroyed when the hall burned, including a plumbing shop, a cigar manufacturer, and a barbershop. Some of the other areas destroyed were a billiard parlor, a band room, a dentist, law offices, and many function rooms.

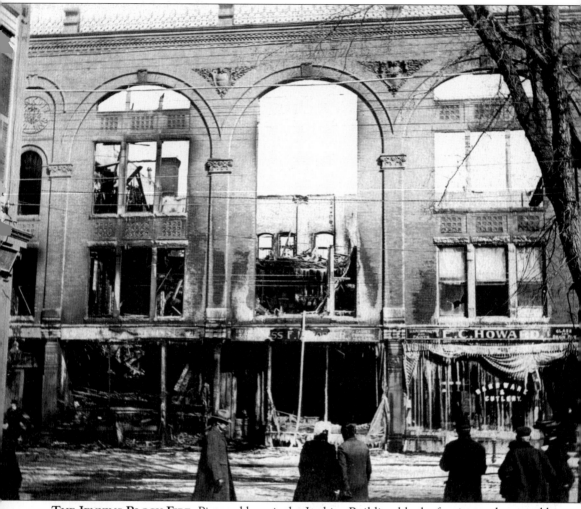

THE JENKINS BLOCK FIRE. Pictured here is the Jenkins Building block after it was destroyed by fire in 1930. The blaze was fought by firefighters from Whitman and surrounding towns and took 19 hours in the bitter cold to extinguish. The landscape of the downtown business district was forever altered by this disaster.

THE G.A.R. HALL FIRE. In 1974, the Grand Army of the Republic hall burned in a spectacular blaze. Located on Hayden Avenue across from the park, the hall stood on the location of the current senior center.

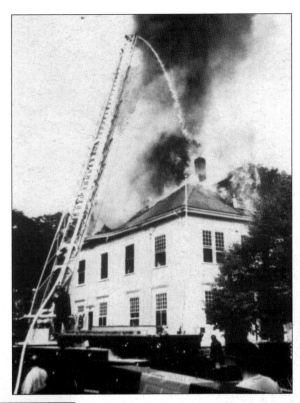

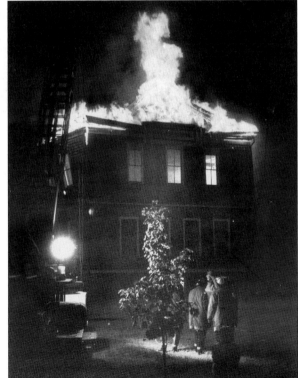

THE DYER SCHOOL FIRE. The Dyer School burned in 1983 after it had just been inventoried for the state historical inventory. The building was razed shortly after, and a new town library was built on the former school grounds on the corner of Webster and School Streets.

103

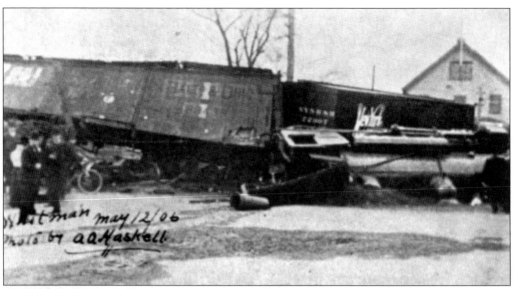

THE TRAIN WRECK IN THE EAST END, MAY 12, 1906. A massive train wreck occurred in the east end of town on May 12, 1906. The wreck, which was at the train depot near the track crossing on South Avenue, resulted in the death of one man who was talking to the crossing tender. As seen in the two views here, the wreck caused quite a mess and disrupted train service for many days.

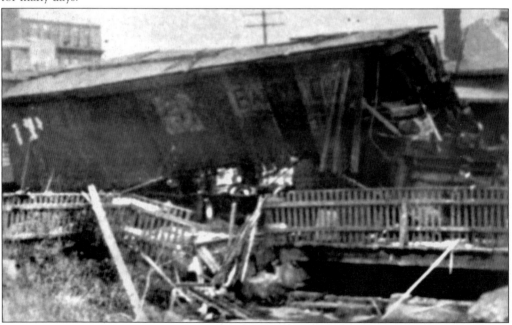

"I Pledge Allegiance to the Flag." Throughout the town's history, its patriotism has always been evident. In this photograph, Old Glory is proudly marched through the streets during a patriotic parade.

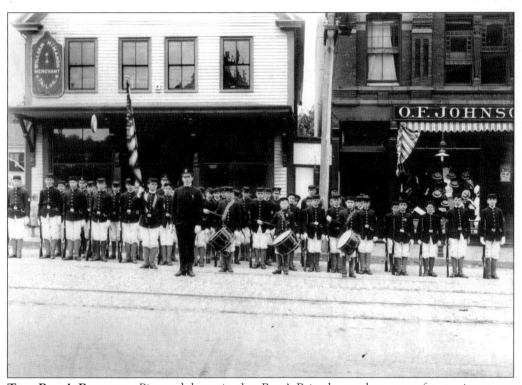

The Boys' Brigade. Pictured here is the Boys' Brigade as they pose for a picture on Washington Street prior to marching in the 1912 Children's Day parade. These fine young men represented themselves only as proud soldiers could.

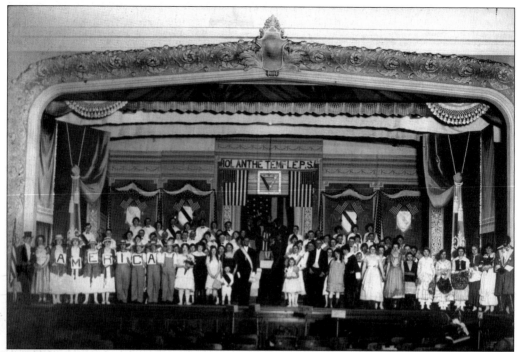

THE PYTHIAN SISTERS MINSTREL SHOW. Performing in the town hall auditorium on April 1, 1918, is the Pythian Sisters Minstrel Show. All of the participants fill the stage as they pose for this post-performance photograph.

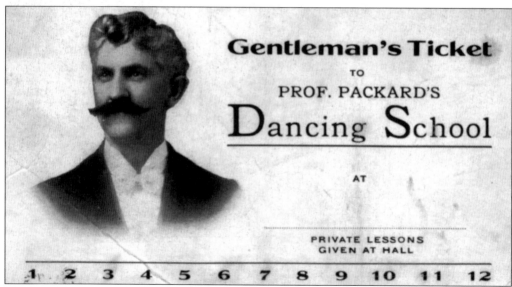

A DANCING SCHOOL TICKET. In addition to operating his store on Washington Street, Ed Packard provided dance lessons to the town's gentlemen. Here is a ticket to attend Professor Packard's Dancing School, which was located in the village hall.

COL. WILLIAM J. HOWARD SQUARE. In honor of a decorated military man, a local square is dedicated to Col. William J. Howard, Bruce Anderton's father-in-law. The square is located near the junction of Washington Street and South Avenue.

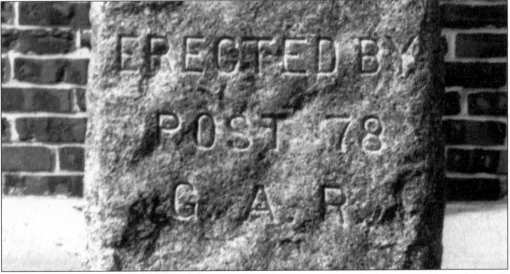

THE COMPANY E 4TH REGIMENT OF THE M.V.M. In honor of the first to answer Lincoln's call, a granite pillar was placed on Washington Street across from Whitman Avenue by the G.A.R. Post 78. The inlaid plaque reads, "This Piece of Granite Marks the Spot Where Stood the Right of Company E, 4th Regiment, Massachusetts Volunteer Militia, on the Morning of April 16th, 1861. This Company Was the First Organized Body of Troops to Respond to President Lincoln's Call on the 15th. They Reported in Boston Ready for Duty at 8:15 A.M. on the 16th."

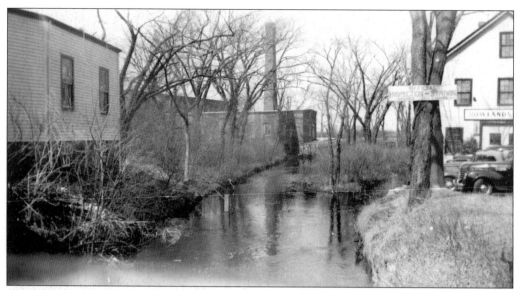

HOBART'S CANAL. Prior to the introduction of steam power, which allowed businesses to branch out from the limited river locations, water provided all the necessary power to satisfy the various manufacturing needs. Pictured here is Hobart's Canal, which turned the wheel to generate the power needed to operate Col. Aaron Hobart's sawmill.

THREE GENERATIONS OF HOBARTS. In 1984, the Whitman Historical Commission placed a marker near the junction of South Avenue and Pleasant Street. It reads, "Three Generations of Hobarts Operated at This Site. Isaac Hobart—Saw and Grist Mill—1731, First Industrial Tunnel & Canal—1745, Col. Aaron Hobart—Wale Plank for the Frigate *Constitution*—1794, Benjamin Hobart—Woolen Mill—1813, First Tack Factory—1816. Burned—August 1859."

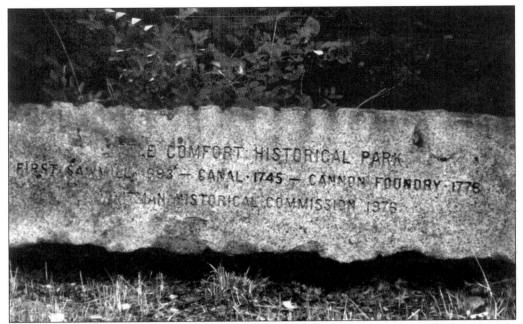

THE LITTLE COMFORT HISTORICAL PARK. Located on Pond Street near South Avenue, the Little Comfort Historical Park marker was placed by the Whitman Historical Commission in 1976. The stone slab reads, "Little Comfort Historical Park, First Sawmill 1693—Canal 1745—Cannon Foundry 1776."

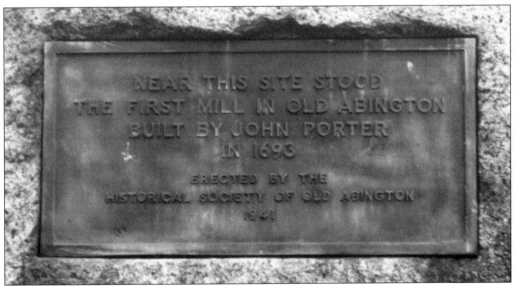

THE FIRST MILL IN OLD ABINGTON. Erected in 1941 by the Historical Society of Old Abington on South Avenue, this historical marker reads, "Near This Site Stood the First Mill in Old Abington Built by John Porter in 1693."

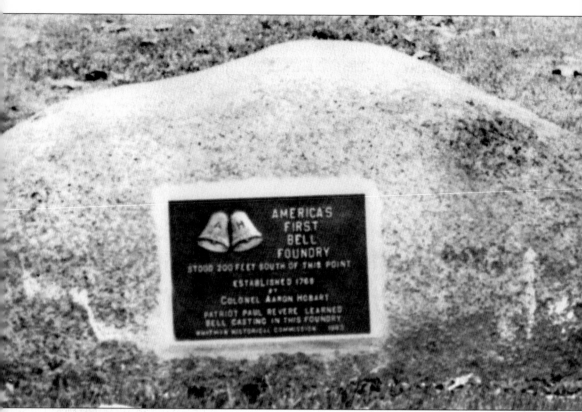

AMERICA'S FIRST BELL FOUNDRY. Placed at the junction of South Avenue and Old South Avenue by the Whitman Historical Commission in 1983, this marker signifies the location of America's first bell foundry. The marker reads, "America's First Bell Foundry Stood 200 Feet South of This Point. Established 1769 By Colonel Aaron Hobart. Patriot Paul Revere Learned Bell Casting in This Foundry."

Ten

TOWNSFOLK

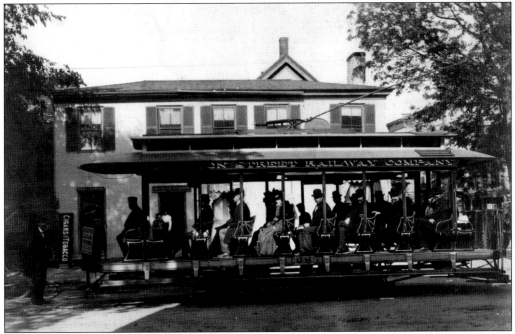

THE BROCKTON RAILWAY COMPANY TROLLEY CAR, C. 1910. Headed north up Washington Street, the Brockton Railway trolley stops to pick up passengers in front of the Dyer Block. In the background is the doorway for the Whitman post office. This is the same location as today's Duval's Pharmacy.

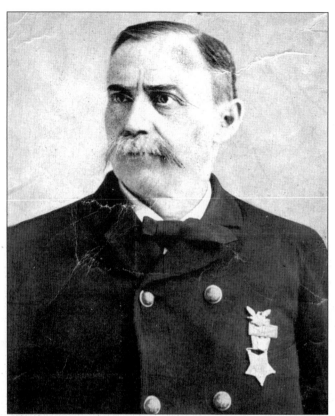

CAPT. CHARLES F. ALLEN.
The leader of the Company E 4th Regiment of the Massachusetts Volunteer Militia, Capt. Charles. F. Allen lived at 113 Temple Street. Allen bravely led his troops from Whitman (then part of Abington) to Boston and into history as his company was the first to respond to President Lincoln's call for duty in the Civil War.

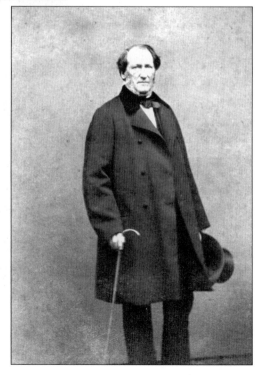

COL. AARON HOBART, 1729–1808. By 1769, Col. Aaron Hobart had established himself as the first regular bell caster of church bells in America. Hobart would also play a prominent role in the Revolution as he provided the government with cannons in preparation of the Revolutionary War. When the famous Paul Revere offered to recast the bell at the Second Church of Boston in 1792, he came to Hobart to learn the craft.

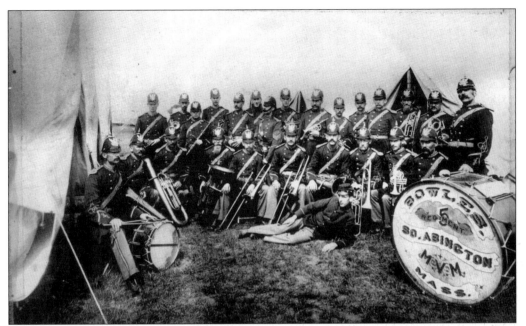

THE SOUTH ABINGTON 5TH REGIMENT M.V.M. BAND. Formed and managed by William A. (Billy) Bowles, pictured here in the 1880s is Bowles's 5th Regiment South Abington Massachusetts Volunteer Militia brass band. Band leader Billy Bowles was the proprietor of a music store in town from 1890 until *c.* 1910.

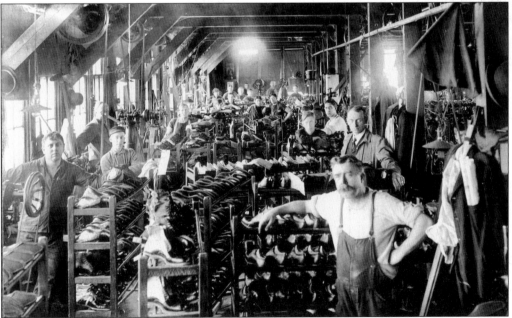

EMPLOYEES OF THE REGAL SHOE COMPANY, SOUTH AVENUE. In 1959, the company moved its shoemaking business to Illinois, and the town lost roughly 600 jobs. The factory had been the backbone of the town's economy since the L.C. Bliss Company brought the plant to Whitman in 1896. Pictured here are workers in the early 1900s, when the company was at the pinnacle of its success. The Regal Shoe factory was demolished in 1972.

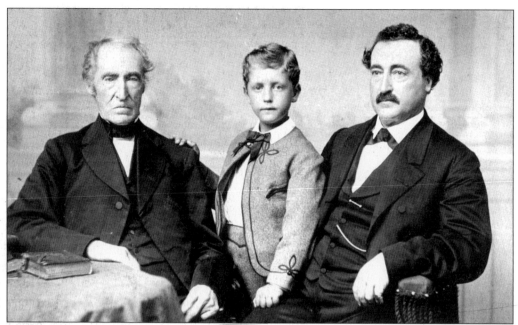

BENJAMIN HOBART. Manufacturer and historian Benjamin Hobart carried on both traditions started by his father, Col. Aaron Hobart. He wrote and published a book in 1886 entitled *History of the Town of Abington*. Pictured here are, from left to right, Hobart, his grandson, and his son-in-law.

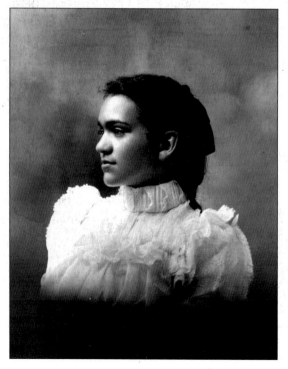

LEILA GURNEY, C. 1900. A descendent of the prominent Gurney family, Leila Gurney was a schoolteacher in town and was regarded as Whitman's first official historian. She graduated from Whitman High School in 1899. At the time of her death, she was working on a history of the town.

PLAYING AT THE WHITMAN FOUNDRY. Pictured outside the Whitman foundry *c.* 1900, these seven unidentified children never had a lack of items to play with while perusing the foundry yard. Located in the east side of town on Raynor Avenue, the foundry is still in full operation today.

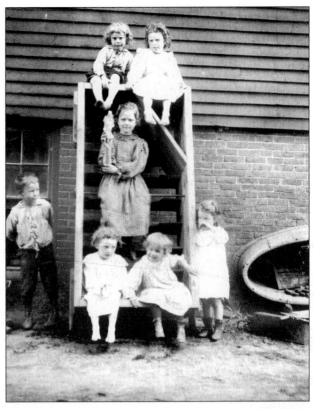

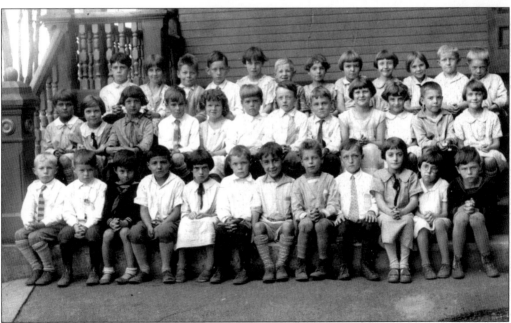

REED ELEMENTARY SCHOOL STUDENTS, THE LATE 1920s. Sitting outside the Reed School on Pleasant Street in the late 1920s, these elementary students patiently wait for the photographer to finish their class picture so they can resume recess.

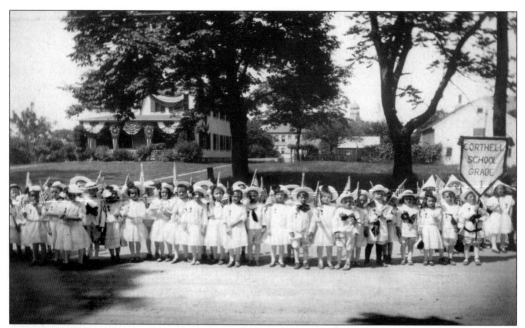

THE CORTHELL SCHOOL, THE FIRST GRADE. Lined up and ready to go are the first-grade students of the Corthell School. Posed here in what can be described as a postcard for the ages, they prepare for the 1912 Children's Day parade to begin.

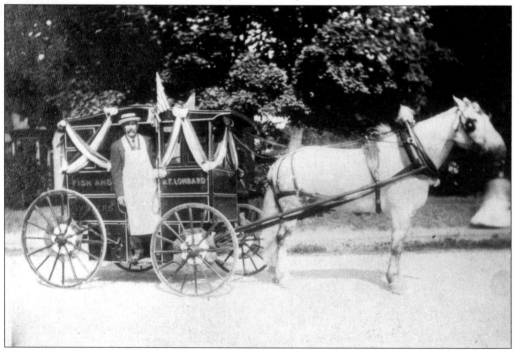

THE FISH PEDDLER BEN LOMBARD, C. 1912. With his modern transportation system, the fish peddler could deliver fresh fish at his customers' doorsteps. Pictured here in 1912, his wagon is decorated and ready to participate in the 1912 bicentennial parade to celebrate Abington's 200th anniversary. In his later years, Lombard resided in the Pleasant Manor Nursing Home.

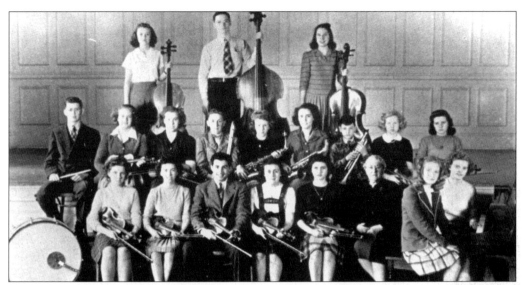

THE WHITMAN HIGH SCHOOL ORCHESTRA, 1944. Led by music department teacher Minnie H. McCarthy is the 1944 high school orchestra. The members are, from left to right, (front row) Leah McLaughlin, Joanne Higgins, Harry Terzian, Nancy Wright, Pauline Phillips, Minnie McCarthy, Grace Avery, and Phyllis Monahan; (middle row) Fred Dake, Meredith Peterson, Dorothy Brittain, Robert Buckley, Gloria Loud, Patricia MacEachron, Edward Clark, Constance Taylor, and Rose Fulginetti; (back row) Phyllis Torrey, George Bayley, and Annie Rudolph.

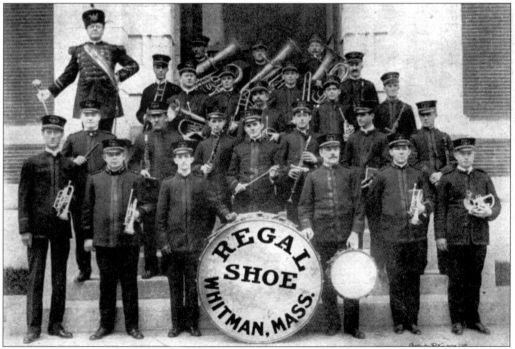

THE REGAL SHOE COMPANY BAND, C. 1908. Like many other companies of the day, the Regal Shoe Company expressed their pride through its band. Under the direction of M. Clifton and manager R.E. McDermott, the band performed at a wide variety of events, including playing at the town hall cornerstone laying celebration.

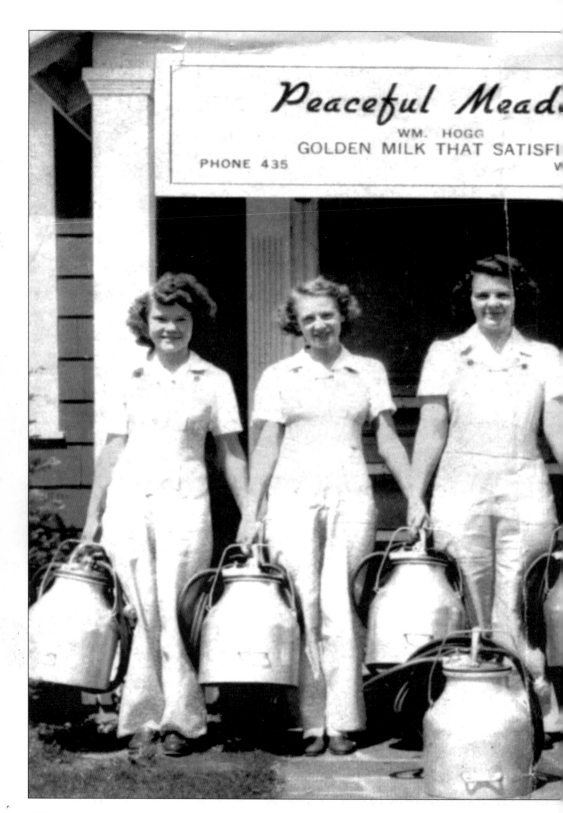

THE PEACEFUL MEADOWS FARM, BEDFORD STREET. At the time of the town's incorporation in 1875, Peaceful Meadows was known as the Gladden Bonney place. For many decades, patrons have enjoyed the variety of fresh ice cream flavors while touring the barn to visit the newborn calves. Pictured with their trusty milk jugs are, from left to right, Amy, Betty, Nellie, Francis, and Wilma, the proprietor's daughters.

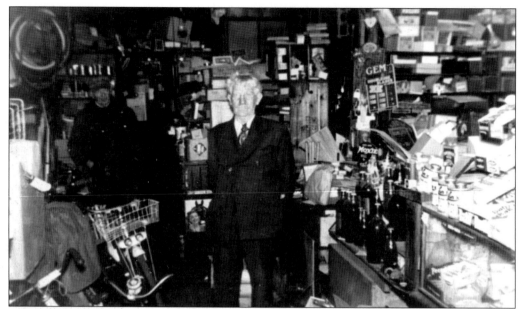

EVERYONE'S FAVORITE UNCLE. Known around town as Uncle Ed, Ed Packard stands in his truly unique emporium. The store was what can only be described as a predecessor to today's Wal-Mart. If you could not find what you needed elsewhere, you probably could get it here.

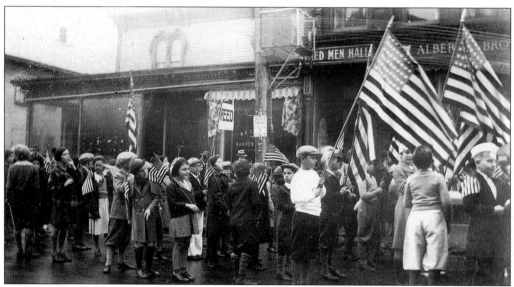

THE ARMISTICE DAY PARADE. In celebration of the signing of the armistice treaty that ended World War I, the citizens hold a parade through the town streets. Pictured here are the patriotic students from the Reed School as they wait on Washington Street for the parade to start.

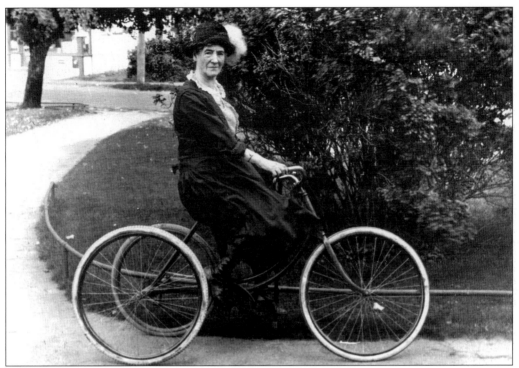

ELIZABETH BOSWORTH. Lizzie Bosworth taught first grade here beginning in 1880. Having been somewhat crippled by an affliction with Polio, Bosworth peddled around town on her oversized tricycle.

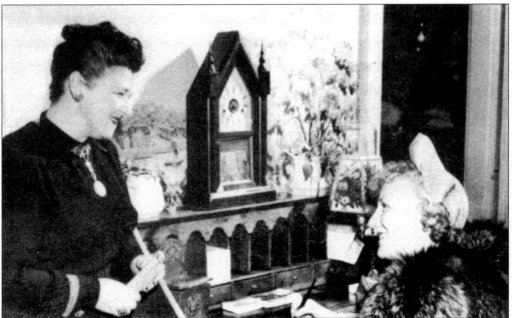

RUTH WAKEFIELD. Always the courteous hostess, Ruth Wakefield greets Mrs. H.V. Beeker as she signs the guest book at the Toll House. Wakefield hosted many regulars, as well as famous people like Rocky Marciano and Duncan Hines.

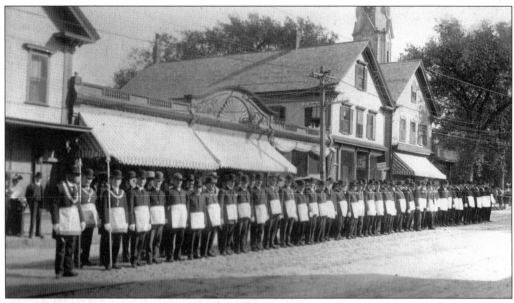

THE PURITAN LODGE A.F. AND A.M. Lined up and ready to go to the town hall cornerstone laying on September 29, 1906, are the members of the Puritan Lodge A.F. and A.M. Here, they pause briefly before they begin their march.

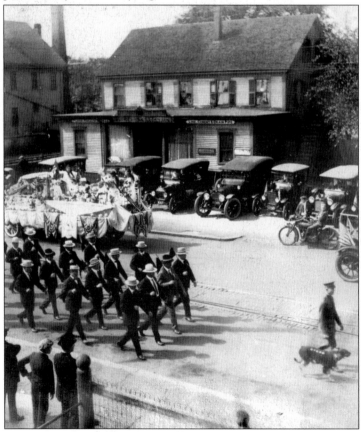

SOUTH AVENUE, THE NORTHEAST SIDE, THE 1920s. In this shot from the Regal Shoe building, cars are lined up as some residents watch a parade. The building pictured here is in the same location of the former McGrath's and current Savill's Hardware store.

JACK NICKLAUS, THE 1970s. During the 1970s, the world's best golfer would arrive by helicopter to participate in public-relations events for his golf shoe line, which was manufactured in town. After landing in the parking lot at the corner of Broad and Marble Streets, Nicklaus would tour the factory and pose for several publicity photographs.

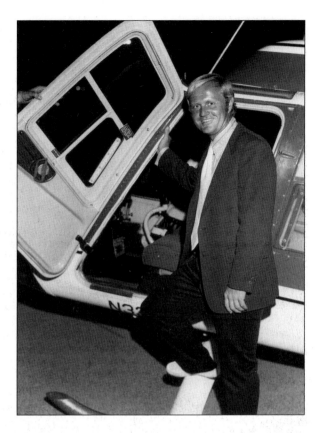

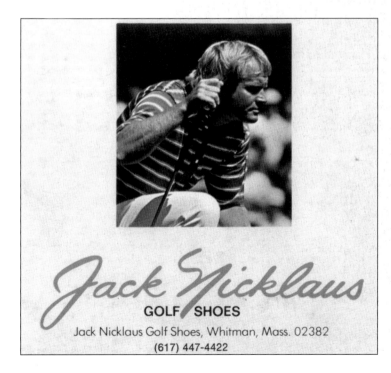

Jack Nicklaus
GOLF SHOES
Jack Nicklaus Golf Shoes, Whitman, Mass. 02382
(617) 447-4422

JACK NICKLAUS GOLF SHOES, THE 1970s. This photograph appeared on the back of a brochure that featured the extensive line of Jack Nicklaus golf shoes, which were manufactured in town. At the time of his association with Whitman, Nicklaus was, without a doubt, the best golfer in the world. The Golden Bear line of golf shoes remains extremely popular to this day.

123

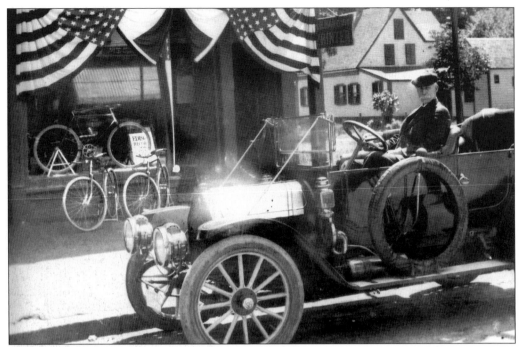

HARRY B. HARDING PRINTING, THE 1930s. Posing here in this fine automobile is everyone's favorite store owner Ed Packard. Packard is parked in front of Harry B. Harding Printing Company at its former Washington Street location. The Harry B. Harding Printing Company has operated from the old Commonwealth Shoe building for many years and is Whitman's oldest printing business.

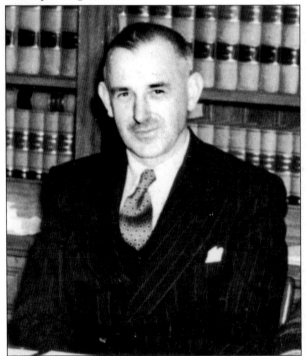

FRANK KANE—SELECTMAN AND BALLPLAYER. Pictured here as a town selectman in 1941 is 46-year-old Frank Kane. Prior to his involvement in politics, Kane reached the major leagues as a member of the Brooklyn franchise of the upstart Federal League in 1915. He later had one at-bat with the New York Yankees in 1919. After the conclusion of his baseball career, Kane coached the Whitman town baseball team while Johnnie Benson was a member.

BATTER UP! Seen here in the late 1920s, the author's grandfather Henry Hickey practices his swing while visiting family on Winter Street. Henry would continue to visit Whitman throughout his lifetime and went on to become the superintendent of the Deer Island correctional facility. Hickey Hollow Lane off of Winter Street was named in honor of the author's great-great grandfather.

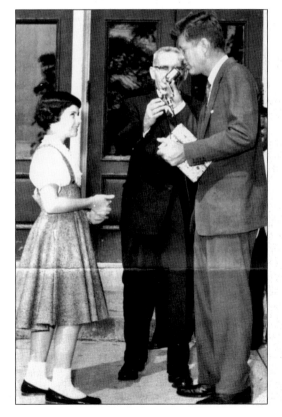

SENATOR JOHN F. KENNEDY. In October 1958, the junior senator from Massachusetts John F. Kennedy came to Whitman and spoke on the steps of the town hall. The future president is pictured here accepting a gift from Judy McGrath while Richard C. Hayes, chairman of the Whitman Democratic Committee, looks on.

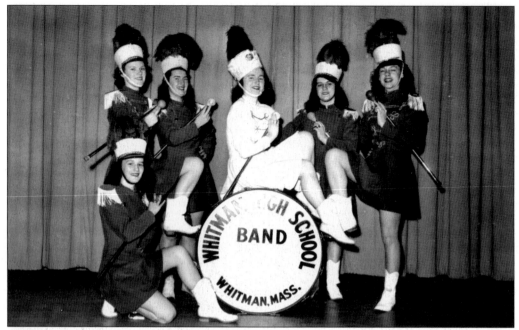

STRIKE UP THE BAND. Just as the Whitman High School band would start to play and march, the drum majorettes would lead the way. Pictured here are the 1944 baton twirlers, who would entertain the crowd with their expert routines.

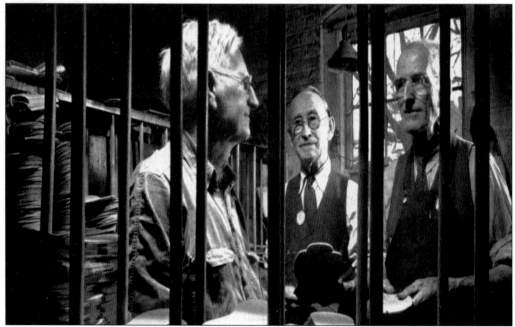

THREE MEN IN A CAGE, C. 1944. At the height of its success, the Commonwealth Shoe and Leather Company employed over 1,200 people in Whitman and in Gardner, Maine. One of the many jobs was to grade the outsoles before they went to production. Pictured here are, from left to right, Joseph Burke, Peter Conner, and Fred Archibald. At the time of this picture, these three men had a combined 63 years of continuous service.

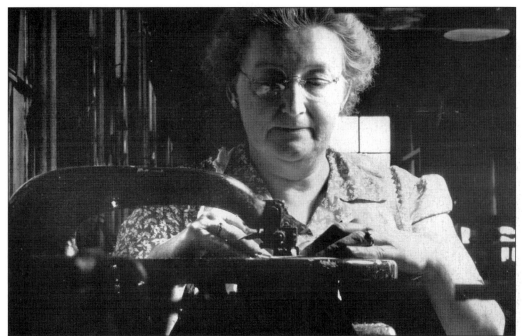

Is That a Victrola? Operating what looks remarkably like a Victrola record player is Bertha Lindsay, who, at the time of this 1944 photograph, was a 20-year Commonwealth Shoe veteran. This modern shoemaking machine would fold all exposed edges of the uppers, giving a soft face to the finished uppers.

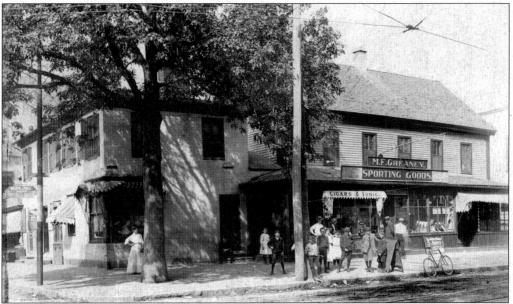

The Dyer Block, the Corner of South Avenue and Washington Street, c. 1890. The center of town has always been a place for adults and kids alike to congregate. Here, outside of Greaney's Sporting Goods, children take a break from their activities long enough to have their picture taken. The building on the left housed one of the early post offices and was razed in 1926.

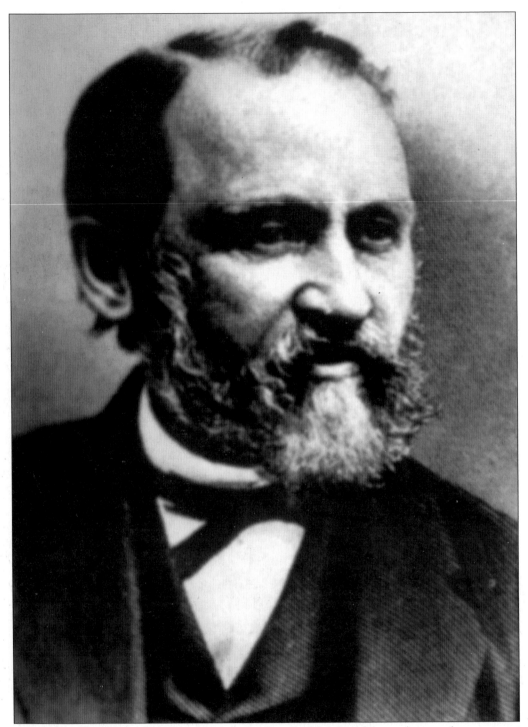

AUGUSTUS WHITMAN. In what can only be described as the ultimate honor, the town was renamed Whitman in 1886 to honor a prominent local family. Augustus Whitman donated the land for the park to the residents of the town and also generously donated to his church. After being thrown from a carriage in 1880, he died at the age of 59.